BACKROADS

of

NEW JERSEY

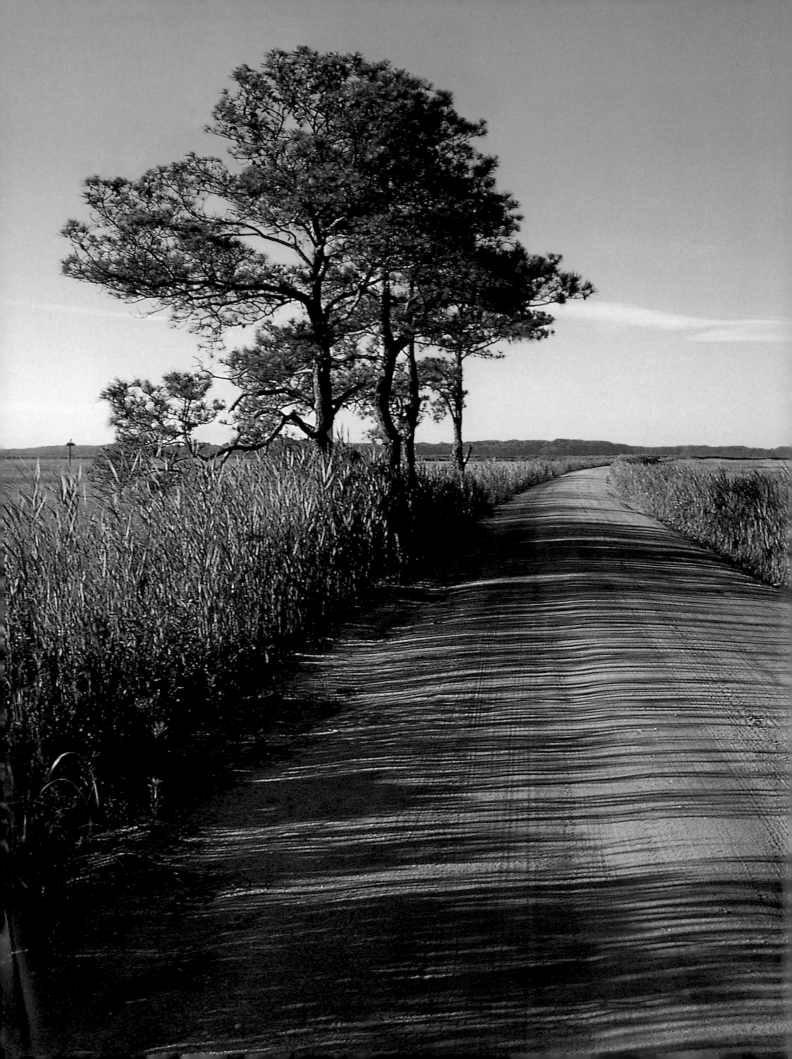

BACKROADS

— of —

NEW JERSEY

*Your Guide to New Jersey's Most
Scenic Backroad Adventures*

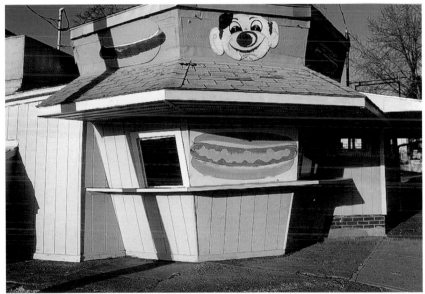

TEXT BY **Robert Heide and John Gilman**

PHOTOGRAPHY AND ADDITIONAL WRITING BY **Paul Eric Johnson**

Voyageur Press

DEDICATION

For Stephen "Hoop" Hooper of Clifton, New Jersey,
who drives the Jersey backroads in his celebrated art cars with great intensity,
focus, enjoyment, and first-hand knowledge of the state.
— RH and JG

For Lester Robert Johnson, family travel photographer
— PEJ

First published in 2007 by Voyageur Press, an imprint of MBI Publishing Company LLC, Galtier Plaza, Suite 200, 380 Jackson Street, St. Paul, MN 55101 USA

Voyageur Press titles are also available at discounts in bulk quantity for industrial or sales-promotional use. For details write to Special Sales Manager at MBI Publishing Company, Galtier Plaza, Suite 200, 380 Jackson Street, St. Paul, MN 55101 USA.

To find out more about our books, join us online at www.voyageurpress.com.

Library of Congress Cataloging-in-Publication Data

Heide, Robert, 1939-
 Backroads of New Jersey : your guide to New Jersey's most scenic backroad adventures / text by Robert Heide and John Gilman ; photography by Paul Eric Johnson.
 p. cm.
 Includes index.
 ISBN-13: 978-0-7603-2954-2 (softbound)
 ISBN-10: 0-7603-2954-0 (softbound)
 1. New Jersey—Tours. 2. Scenic byways—New Jersey—Guidebooks. 3. Automobile travel—New Jersey—Guidebooks. 4. New Jersey—Pictorial works. I. Gilman, John, 1941- II. Title.
F132.3.H46 2007
917.49'0444—dc22
 2006101679

Editor: Margret Aldrich
Designer: Brenda C. Canales
Maps by Mary Firth

Printed in China

ON THE FRONT COVER: The old road bends around an older sycamore tree in Assunpink Wildlife Management Area, a natural oasis in the suburbs.
ON THE BACK COVER: (top) View from Washington Rock, First Watchung Mountain; (bottom left) Miss America Diner in Jersey City; (bottom right) sunflowers on the dunes at the U.S. Life Saving Station, Sandy Hook.
ON THE TITLE PAGE: New Jersey's Pinelands meet the Delsea saltmarshes along Jake's Landing Road, which goes from Belleplain State Forest to the Dennis Creek Wildlife Management Area.
TITLE PAGE, INSET: New Jersey enjoys more than its share of roadside vernacular architecture, like Toby's Cup in Phillipsburg.

CONTENTS

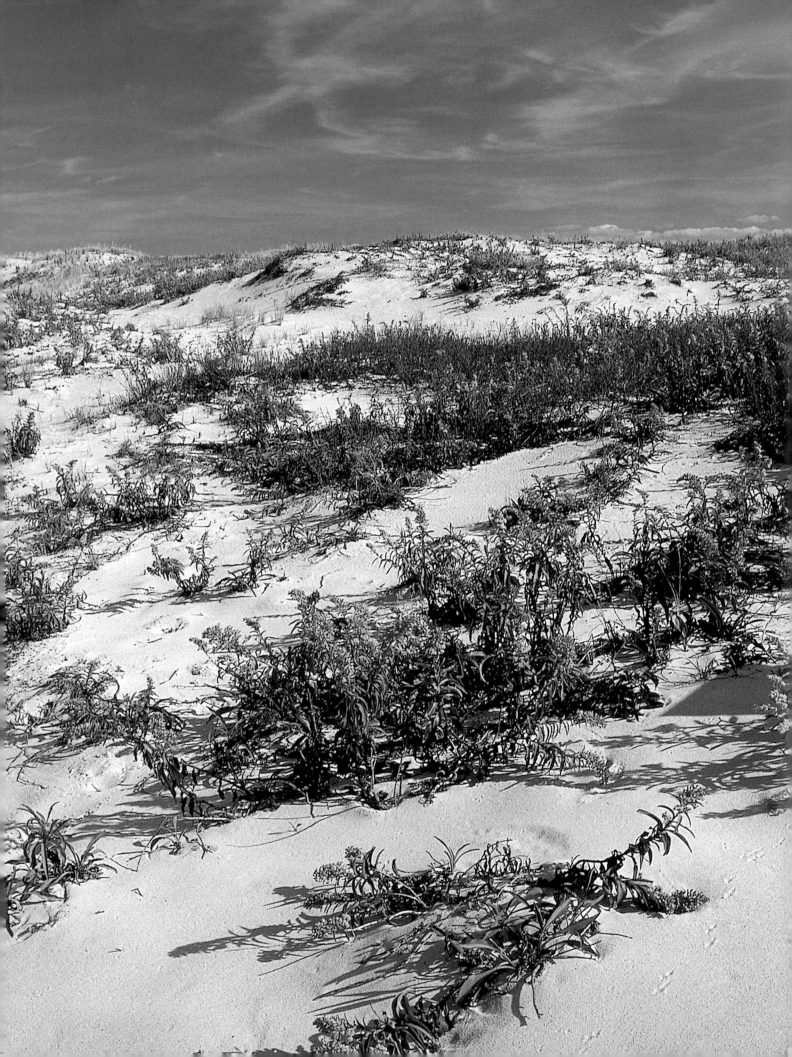

INTRODUCTION

ABOVE:

Seafood in Beach Haven Terrace on Long Beach Island.

FACING PAGE:

Seaside goldenrod highlights a back-dune swale at summer's end on Island Beach.

"I've been a lot of places,
Seen pictures of the rest.
But of all the places I can think of
I like Jersey best."
—Lyric from "I Like Jersey Best," by Joseph Cosgriff

Benjamin Franklin once likened New Jersey to "a beer-barrel keg tapped at both ends," sandwiched between the bustling cities of New York and Philadelphia. But the great state of New Jersey has plenty of personality, excitement, and history of its own.

One of the original thirteen colonies, many of the famous battles of the American Revolutionary War were fought here. In 1776, General George Washington and his troops made their famous crossing over the ice-clogged waters of the Delaware River to defeat King George III's troops in a surprise attack at Trenton. This victory is considered to be a pivotal turning point in the American Revolution. The region known as New Jersey achieved statehood on December 18, 1787, and the sense of its past before, during, and after the Revolutionary War can be found in historic towns like Bordentown, Morristown, and Princeton.

Early settlers colonizing New Jersey included trappers, miners, Dutch farmers, British Puritans, Quakers, and Swedish Lutherans, as well as German, Irish, and Italian immigrants. At the end of the nineteenth century Eastern European Jews settled into New Jersey cities like Newark and Elizabeth. By the mid-twentieth century another strong influx from Puerto Rico, Cuba, Mexico, and other Latin-American countries brought new workers in the Jersey factories, later followed by skilled workers from Asia, Russia, and India. Today, New Jersey is the most densely populated of the fifty states.

New Jersey is a complex and diverse place that has been called a microcosm containing elements of all the other states. Co-existing with industry, technology, and science research centers are bountiful farmlands, woodland forest preserves, scenic lake country, and an extraordinary 127-mile Atlantic Ocean shoreline with glistening white-sand beaches. As the eagle flies, the tiny state of New Jersey is 166 miles from top to bottom and only 32 miles wide at its narrowest point. The state's western border with Pennsylvania is defined in its entirety by the Delaware River. With the exception of the 50-mile-long northern border with New York State, New Jersey's 8,244 square miles are completely surrounded by water. The fifth smallest state, New Jersey has over six hundred state parks and wildlife management areas. It is known as the "Garden State" and works overtime to maintain high standards when it comes to protecting its precious natural environment. Agriculturally, the state is famous for the Jersey tomato, which competes along with Jersey's silver queen white corn, cranberries, and blueberries to be the finest in the land.

The official state seal of New Jersey depicts Ceres, the Greek goddess of agriculture, and a horsehead, the horse being the official animal of the

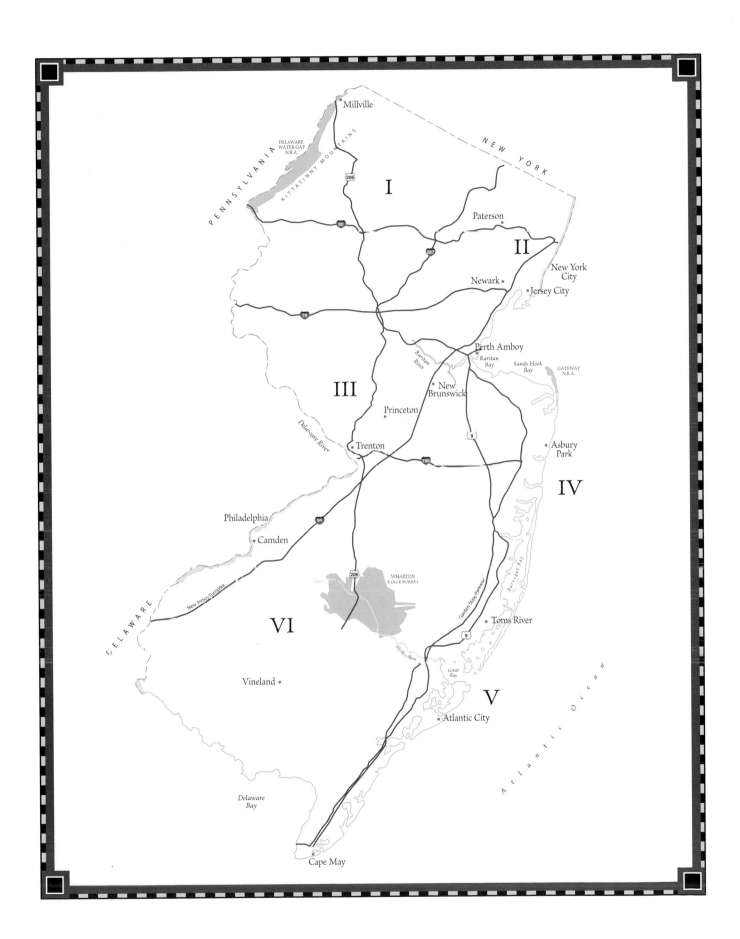

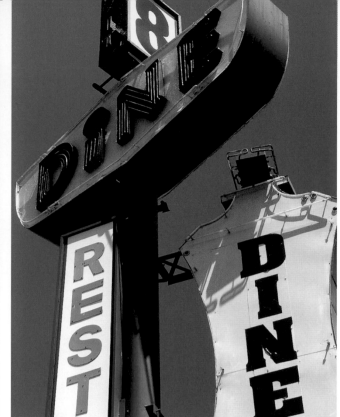

ABOVE: *The Neldon-Roberts House in Montague, once used as a schoolhouse, illustrates an architectural style typical of early Dutch settlements on the frontier.*

TOP RIGHT: *The Exit 8 Diner (formerly Mom's Peppermill), halfway between Boston and Washington, D.C., began as a lunch shack during construction of the New Jersey Turnpike.*

RIGHT: *Rich in the chestnut oak of harsh mountain tops—as well as red, black, and scarlet oaks and mockernut, pignut, and shagbark hickories—the forested ridges of the Kittatinny Mountains provide a plentiful bounty for a growing black bear population.*

ABOVE: *Fresh, local produce often finds a market no farther than the finest restaurants of Manhattan or Philadelphia.*

LEFT: *The upland tributaries of the Raritan River, with their abundance of moving water, helped to promote early industry on widely scattered mill sites.*

When traveling along New Jersey's backroads, old highways, and byways in a touring sedan, economy car, or maybe even a classic automobile like a 1950s Chevy, hunger will soon set in. A growl in the stomach or a call from the kids for a coke to quench their thirst signals that it is time to stop driving and time for a respite. We are not talking about a fine-dining experience in an upscale restaurant, or even a middle-range family-style establishment, and certainly not a fast-food chain or a slice-uh-pizza joint. In our humble opinion, the classic diner—Jersey style—is the order of the day before or after a long, happy journey.

Diners have been an American institution since old railroad and trolley cars were first converted into eateries. The fare still usually includes eggs with home fries, bacon, and toast; a hamburger platter with French fries; a hearty meatloaf with mashed potatoes and gravy; and, yes, a mile-high slice of lemon meringue pie with that must-have steaming-hot cup of diner coffee, usually served in a ceramic mug. Chatty diner waitresses are often a lot of fun, and sometimes there is a mini jukebox at the table. If you are in luck, you might be able to hear hits like "Sixteen Candles," or Jersey's own Bruce Springsteen singing "Born to Run," or "Jersey Girl."

Most diners are twenty-four-hour deals, so keep your eyes open for these bright, neonized eateries as you drive along the road. Diner aficionado Richard J. S. Gutman, author of *American Diner*, says that there are more than four hundred classic diners in the state of New Jersey, and we are sure there are many more to be found. It should be noted, however, that many of the old-style glass-block and chromium "Streamliners" can disappear in a flash—some transported to other states, with some even shipped to countries like Japan and Germany, where there is a fascination with American popular culture. Take advantage of these beauties while you can, and be sure to stop for a bite to eat on your travels through the Garden State.

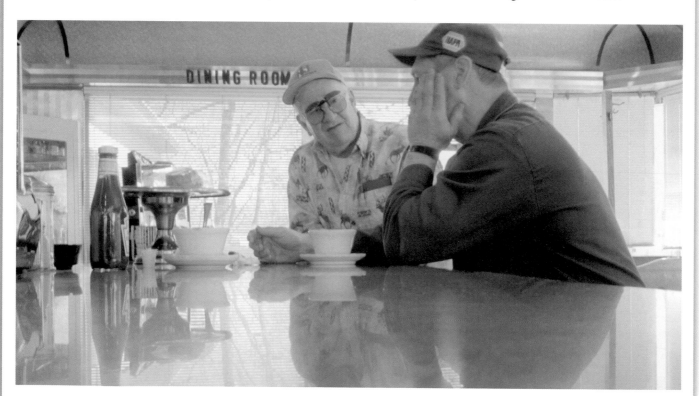

No trip through New Jersey is complete without a visit to a classic diner. Here, two patrons of the Crossroads Diner in Bridgeville sit a spell over a cup of coffee. Photograph by Paul Eric Johnson

state. Other official designations are the state bird, the Eastern Goldfinch; the state flower, the common meadow violet; and the state tree, the red oak, which is found all along the beaches and the estuarial waters of the coastline. Alas, the state has no officially designated song, although some attempts were made in the legislature to push forth "Born to Run," by Jersey native Bruce Springsteen. In the 1940s, "The Jersey Bounce" had been considered, and today the popular "I Like Jersey Best," written by Joe Cosgriff and recorded by John Pizzarelli, is the latest contender. First suggested in 1983, this song is still under serious consideration in the halls of the capitol in Trenton.

There are many reasons to "like Jersey best." One travel writer referred to the Jersey shore region as New York's California, and now that gas prices have risen, residents of the tri-state area—New York, Connecticut, New Jersey—and outlying "locked in" states, like Pennsylvania and Ohio, are driving to the Jersey shore for a summer vacation that is easier on the budget than more distant spots. During the summer months the ocean, the beaches, and the famous boardwalks at the shore are just perfect, be it at Sandy Hook, Asbury Park, Ocean Grove, Seaside Heights, Atlantic City, Wildwood, or Cape May.

Some detractors like to think of New Jersey as an industrial wasteland, but what is called the "industrial belt" is a relatively narrow corridor stretching across the middle of the state, from New York to Philadelphia. Once out of this immediate industrial zone and off of the New Jersey Turnpike, there is more than enough for motorists to enjoy that is invigorating, abundant, and unique in a scenic sense.

A word to the wise as you traverse the backroads and highways: Drive slowly, carefully, and somewhat defensively in a land where the message is often "Faster! Faster!" Some motorists will want to do a quick-jump and travel on major roads and interstates in order to get to the backroads we recommend. (And why not?) It is a good idea to have a Jersey map handy; and hey, if confusion sets in, just stop on a street corner, at a local gas station, or maybe at a Jersey diner and find out where you are and how to get where you are going. If you choose to look at your map at the counter of a diner, don't forget to order a cruller and a cup of "diner coffee" to send you on your way.

The thing to remember—if you don't know it already—is that Jersey is really a fun place to vacation, travel, and explore, be it a day trip, a weekend, a week, or more. Relax, sightsee, have a good time, and enjoy the passing scenery just as Grandma and Grandpa did when they hit the road in a touring sedan . . . and don't forget to sing along with your auto tape or CD with "I Like Jersey Best."

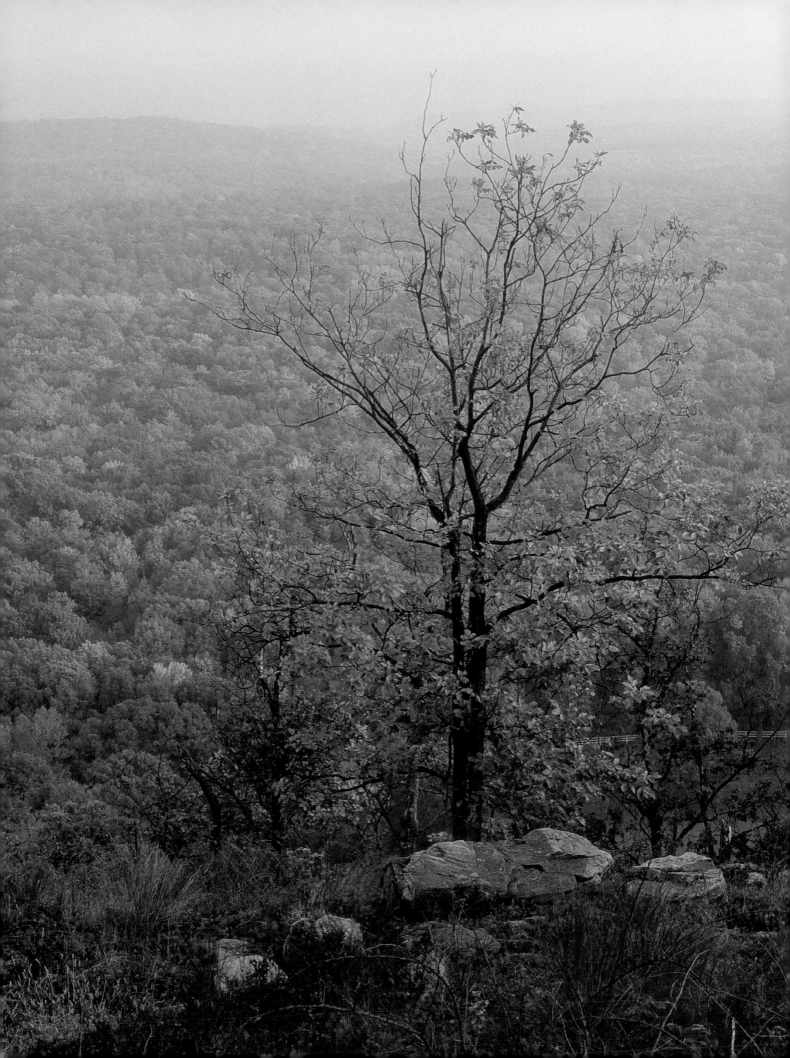

THE NORTHERN HIGHLANDS
LAND OF LAKES AND
MOUNTAIN GREENERY

ABOVE:

Deer flourish on the edges of New Jersey's woodlands, such as this one near Wick House in Jockey Hollow.

FACING PAGE:

The Appalachian Trail passes along the Kittatinny Ridge, offering views of the Paulins Kill Valley and, on a clear day, the skyscrapers of New York City on the horizon.

The northwest region of New Jersey is a part of the Appalachian "province" of the Great Atlantic Slope. The highest part of the state is the rugged Walpack Ridge—a wall of rock bordering the Delaware River—and the heavily forested Kittatinny Mountains rise to 1,804 feet in the corner of the state. The Delaware River cuts a mile-wide gorge through quartzite rock at the point where the Kittatinny Mountains cross over into Pennsylvania and are called the Blue Mountains. To the east lies the Great Valley of the Appalachians, which extends from the Hudson River in upstate New York southwest to central Alabama. East of that, the broad, rounded, and flat-topped ridges of the geologically older Highlands are crossed by swift, clear rivers and streams. Dark glacial lakes and deep ponds dot the valley landscapes. Even though it's so close to the teeming megalopolis of New York City, this is a region rich in natural beauty.

WATER ON THE MOUNTAIN
NEW JERSEY'S NORTHERN BORDER

Ringwood State Park is an excellent place to begin your tour of northern New Jersey. The five-thousand-acre park features mountains, streams, lakes, swamps, and scenic overlooks—which can be enjoyed from clearly marked and maintained trails—as well as two historic manors.

The park is divided into two sections, with Ringwood Manor to the west and Skylands Manor to the east. The Skylands Manor was acquired in 1891 by a New York lawyer named Francis Lynde Stetson. After Clarence McKenzie Lewis bought the estate in 1922, the original Victorian structure was torn down and a new manor house was built in 1924, designed in the extravagant Jacobean manner by John Russell Pope. The property was restored as a working farm with a rose garden, golf course, orchard, and twenty thousand evergreens. From the back of the house, the formal Terrace Gardens, the Octagonal Garden, bronze fountains, and pools beckon, and self-guided hiking trails abound. In 1966 the state bought the property, and in 1984 it became New Jersey's official botanical garden.

The history of the Ringwood section of the park is equally fascinating. In the sixteenth and seventeenth centuries, the forest trees in the Ramapo Mountains were cut down to feed Ringwood Company's furnace, the first blast furnace in the country. It forged blue iron ore mined in the region for the manufacture of weaponry during the Revolutionary War. Washington planned the main route from Morristown to West Point to include stops at Ringwood and, on several occasions, used the 1740 colonial manor house as his headquarters. Ringwood ironmaster and surveyor general of the Continental Army, Robert Erskine, died in 1780 and is buried on the grounds alongside soldiers who died fighting in the Revolutionary War.

The furnaces were in operation for over one hundred years, but by the 1880s the area was ored out and the forge villages became ghost towns. The Ringwood Manor house and property passed into the hands of others and was purchased in 1854 by Peter Cooper, founder of Cooper Union Institute,

ROUTE 1

From Ringwood, take Skylands Road west and Sloatsburg Road north to Ringwood State Park. Drive south on Sloatsburg Road, west on Margaret King Avenue, and west on Greenwood Lake Turnpike (County Route 511) to Long Pond Ironworks State Park. Continue on County 511 to Greenwood Lake, then go straight on the Warwick Turnpike to Wawayanda State Park. Take Wawayanda Road through the park, then head south on Breakneck Road and north on County Route 515. Go west on Vernon Crossing Road (County Route 644) to Glenwood Road (County Route 517) north. At Glenwood, drive west and then south on County Route 565 to Glenwood Mountain Road, west to Wallkill Road, and south to Owens Station Road (County Route 642). State Highway Route 284 runs south to Sussex. Take State Highway Route 23 north to Sawmill Road, which runs south to Deckertown Turnpike. Follow Deckertown Turnpike west and Crigger Road south to Sunrise Mountain Road, to U.S. Highway 206. Turn east on U.S. 206 to Culver Lake.

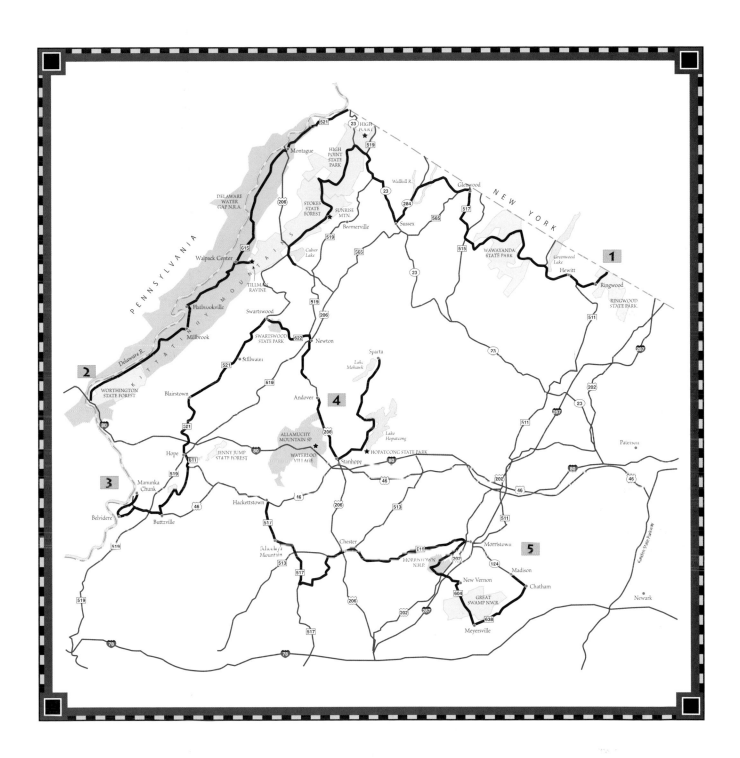

RIGHT: *These New York asters are growing in New Jersey today, but competing claims for land along the border were not resolved until 1769, after decades of skirmishes between the Yorkers and the Jerseymen.*

BELOW: *As it climbs, Sunrise Mountain Road provides surprising views to the upper Delaware Valley, or Minisink of the Lenni Lenape, just over the ridge from this overlook.*

A statue of a boy on a dolphin is tucked into the grotto of a reflecting pool in the gardens at Skylands Manor.

who made it his summer estate. Later, it passed to Abram Hewitt, the last ironmaster at Ringwood. The Coopers and the Hewitts made additions and changes to the house. Outer buildings were appended to the existing house (the original Colonial décor was torn down in 1807 and replaced), a roof was added, and the house was coated with stucco. The impressive home features 78 rooms, 24 fireplaces, and 250 windows.

Like Ringwood, the Village of Hewitt, where Long Pond Ironworks State Park is located, was an iron forge town with houses, shops, schools, and even a church for over one hundred people. Unique here are the early industrial-age iron furnaces and the hydro-power system that replaced them, standing intact side by side.

In 1768 settlers built a dam at the nearby glacial Greenwood Lake to provide energy for the iron mines. Then the Morris Canal builders constructed a bigger dam, and in 1927 a final dam was built. The lake area became known as the "Little Switzerland of New Jersey" or "Switzerland of the East." Greenwood is six miles of aquamarine water, a watershed renewed by rivers and water from the north in New York State. Cottages lining the shoreline and summer recreational activities, including power boating, lured people like Frank Sinatra, who had a summer home here, and Joe Louis, who worked out in the 1940s and 1950s at a Greenwood Lake gym. Beyond the lake, along the Warwick Turnpike in Abram S. Hewitt State Forest, a challenging trail ascends the Bearfort Ridge for spectacular views.

Nearby is Wawayanda State Park, whose name comes from the Lenape word meaning "water on the mountain." The 11,330-acre park includes the Bearfort Mountain Natural Area (1,325 acres); Hemlock Ravine Natural Area (399 acres), a hemlock and mixed hardwood forest; and the Wawayanda Swamp Natural Area, 2,167 acres of cedar swamp, mixed oak, hemlock, and hardwood forest, and northern bog. In the center of the park are the 255-acre Wawayanda Lake and little Laurel Pond. Picnic areas with open-air fireplaces and tables are scattered throughout the park, which contains forty miles of marked trails, including a twenty-mile-long section of the Appalachian Trail. (In the off-season, an alternative to going through the park is to stay on Warwick Turnpike across the state line, then take Route 94 south.)

Wallkill River National Wildlife Refuge, a 4,200-acre preserve, is a visit into a primordial past with abundant wildlife and excellent fishing. The Wallkill Valley was home to the Shawnee and the Munsi Indians, and up until 1757, blockhouses built and maintained by local settlers were necessary for protection from the tribes. The forests, wetlands, meadows, and scrub offer ideal habitat for a great variety of resident and migratory birds. Called "The Drowned Lands" by early Dutch settlers, two major migration corridors for waterfowl also pass through the area.

To encounter wildlife of a different sort, take a short detour off of State Highway Route 23 and head to Beemerville. Located on County Route 519, the Space Farms Zoo and Museum is home to five hundred animals representing over one hundred species—from local woodlands creatures, like black bear, to exotic monkeys and leopards, mountain lions, and wolves. The

zoo was founded in 1927 by Ralph and Elizabeth Space and is now run by the third generation of the Space family. There is also a vintage automobile exhibit, a miniature circus, a merry-go-round, and other attractions geared to young and old alike.

Within High Point State Park's 14,000 acres, 11,312 of which are in the Allendale section of Stokes State Forest, are numerous opportunities for nature walks and recreation. On the crest of Kittatinny Mountain in the far northwest corner of New Jersey, High Point Monument is, not surprisingly, the highest point in the state at 1,803 feet above sea level. The 220-foot monument is located north of glacial Lake Marcia on Monument Drive. There are views south to Sunrise Mountain in Stokes State Forest, west to the Pocono Mountains, north to the Catskill Mountains, and east to the Wallkill River valley. Lake Marcia has a bathing beach, changing rooms, and picnicking with tables and fireplaces. The Dryden Kuser Natural Area, adjacent to the monument, has over 1,300 acres of upland swamp with a circling trail and an old road cutting through the middle.

In its entirety, Stokes State Forest is 15,735 acres and is connected on the west to the Delaware Water Gap National Recreation Area. This is mountainous forest wilderness in New Jersey's wildest region. For sweeping views of the surrounding terrain and the Delaware River, Sunrise Mountain is the place to stop. Stokes has camping facilities, trails, nature preserves, and well-stocked streams for anglers.

In ancient times the wind carved a pass through the Kittatinny Ridge, a gap four hundred feet lower than the crest of the mountains. Today U.S. Highway 206 traverses the gap that was once a Native American trail, and then a roadway built by the early colonists. Here, turn east on U.S. 206 to get to the other side of the gap and Culver Lake. Enjoy the eateries and well-stocked farm stands on this strip from a time when a main road in New Jersey could still be a backroad.

WILD RIVER DRIVE
THE DELAWARE WATER GAP VIA OLD MINE ROAD

The Delaware River is New Jersey's western border. Discovered by Henry Hudson in 1610, the 331-mile-long river originates with two wild-rapids streams in New York State: the Mohocks flowing from the west and the Popaxtunk flowing from the east. The Native American names for the mighty Delaware were *Keht-hanne*, "the greatest stream," and *Laenapewihittuck*, "the river of the Lenape."

The famous Delaware Water Gap, a gorge 1,100 feet deep and carved by the Delaware River through the Kittatinny Ridge, has been an inspiration for generations of painters and poets. It is the focal point of the Delaware Water Gap National Recreation Area administered by the National Park Service, an area encompassing seventy thousand acres and running forty miles alongside both the New Jersey and Pennsylvania sides of the river. Within its boundaries on the Jersey side, it encompasses 6,200-acre Worthington State Forest, 1,527-

ROUTE 2

From the southern end of the Delaware Water Gap National Recreation Area, follow the Old Mine Road (County Route 606) north to Millbrook Village and take a left on County Route 615. At Flatbrookville, take a right on Walpack Road (still County Route 615) to Walpack Center. Go right on Main Street, then straight up the ridge to Tillman Ravine. Return to County Route 615 and go north. Take the left fork onto Walpack Road at Peters Valley Craft Village to rejoin the Old Mine Road. Cross over U.S. Highway 206 to continue north on River Road (County Route 521), just entering New York State. At U.S. Highway 6, go left over the Neversink River and left again to the Tri-States Monument.

RIGHT: *Rhododendrons thrive in the cool, moist hemlock woods of Tillman Ravine.*

BELOW: *The rural community of Knowlton is located in rolling terrain above the Delaware River. The cemetery in the old center is high on a hill with a view to the Delaware Water Gap.*

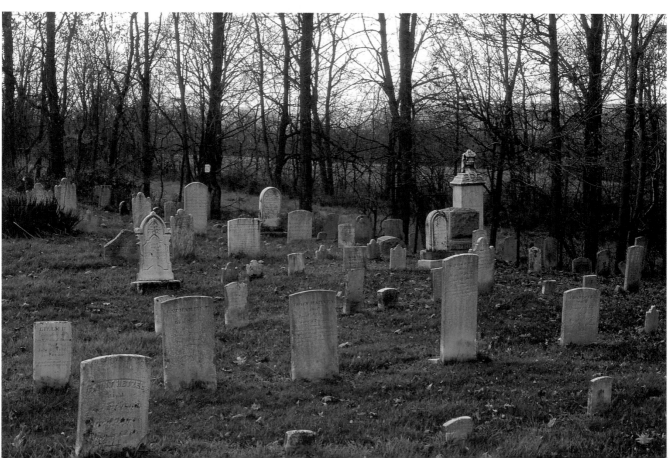

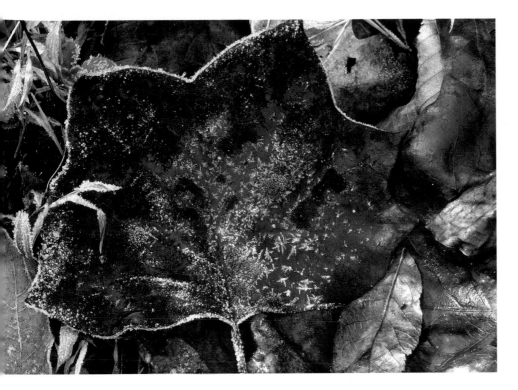

LEFT: *A frost-tinged tulip poplar leaf lies on the forest floor of Kittatinny Valley State Park in autumn. The tallest tree in the woods, tulip poplar is a sure sign of reforested fields and pastures.*

About half of New Jersey's active dairy farms are in Warren and Sussex counties. This land is protected in the Wallkill National Wildlife Refuge, an important stopover for migrating wild geese.

foot Mount Tammany, the great Sunfish Pond, and several wildlife management areas and natural preserves. Here is wilderness on a vast scale, with wildlife that includes black bears, fox, beaver, river otter, and deer. There is also plentiful waterfowl and wild turkey, bald eagles, and several species of hawk, as well as many resident and migratory birds.

The Old Mine Road is probably the oldest turnpike in the country, built by Dutch colonists in the 1600s. The road runs through the Delaware Water Gap National Recreation Area and all the way north to Kingston, New York. As you travel up the Old Mine Road, you will have soaring views of the Delaware River, scenic valleys and ridges, streams and waterfalls, meadows and deep woods. Mine holes still dot the area from the old silver and copper mines.

Originally a Native American trail through what was known as Minisink, the Old Mine Road became a bridle path, and finally the first road for wheeled vehicles in the country. The Van Campen Inn, built around 1746, was a respite for travelers such as John Adams, who found it a comfortable place to stay as he made his way in 1800 from Boston to sessions of Congress in Philadelphia. In 1780 Major Moses Van Campen, who was born in the house, was surprised here and captured by Indians. His father and brother were killed, as was an uncle at a nearby farm. Taken prisoner with two boys, and convinced they were to be burned alive and scalped, the major planned a desperate escape. With the help of the boys they killed nine of their captors, wounding one who got away. In later years the wounded man re-appeared, showing the scar on his back made by the hatchet thrown by Van Campen. It is said these strong and courageous men became good friends.

The U.S. Army Corps of Engineers abandoned plans to dam the Delaware River at Tocks Island in 1975. Sparsely settled to begin with, the valley residents never came back after they were evicted to make way for the reservoir. Homes that weren't razed have been added to others at Millbrook Village, where continuing restoration and re-enactments preserve the life of mid-nineteenth century rural America.

The first gristmill and first sawmill in the county flourished in Flatbrookville in the 1700s; today there is little more than woodland with river views to enjoy, and the dark cover of rhododendron bushes alongside the road. Flat Brook enters the Delaware here, creating a whirlpool called by a variant of the Native American name of *Wallpeck*, or *Walpeek*, meaning "deep water."

Turn onto Main Street in Walpack Center. The Walpack Historical Society maintains a small museum next to the old post office, and only a few of the homes are used for park housing, but the strangely empty farming village with its neat white church remains intact.

Continue on Main Street then over Flat Brook and cross the intersection onto Tillman Road up to Tillman Ravine in the southern section of Stokes State Forest. An easy walking trail, with several convenient bridges, follows the craggy gorge carved along the Kittatinny Mountains by Tillman Brook. Cascading water has scoured out the natural rock wall and worn potholes in the boulders, which the locals call "teacups." An old-growth cover of towering evergreens shelters this

gorge, along with hemlocks, red and white pine (planted by the Civilian Conservation Corps in 1932), laurel, dogwood, profuse rhododendrons, violets, and ferns; all combine to significantly lower the temperature. In the wintertime the splashing brook forms fantastic ice formations.

Hainesville Wildlife Management Area is to the east as you drive the Old Mine Road north. The deer herd is kept in check during the hunting season by archers and gun enthusiasts, who also train their weapons at the black and wood ducks and the pheasants, the latter released annually by the state. In 2005 there was a controversial bear-hunting season as well, with the intention of bringing down the state's population of black bears, of which it is estimated to be over three thousand.

The small town of Montague was originally settled before 1700 by the Dutch and the Huguenots. It was a gristmill and sawmill center when it was given a Royal Patent in 1759. In the nineteenth century it became a beef and dairy center. A fine local museum is located in the Foster-Armstrong House on the left. A little farther on the right, an Old Mine Road historic marker indicates the approximate location of one of the string of blockhouses that were built for protection of the frontier in the French and Indian War. Around a long curve, a dirt road left will bring you to a couple of picnic tables with views of the Delaware River.

Continuing north, you will see the impact and tremendous force of recent floods, evident in the piles of broken tree trunks where they caught on the river's edge. Take a left on U.S. Highway 6 over the bridge and another left on the path through old Laurel Grove Cemetery to the end. Here, at the tip of Carpenter's Point, the Neversink River joins the Delaware, and you'll find the Tri-States Monument marking where New Jersey, New York, and Pennsylvania meet. Stand in three states at once.

RIDGE AND VALLEY
AN EASTWARD DRIVE FROM MANUNKA CHUNK

Manunka Chunk is a historic railroad junction on the Delaware embankment, which was an important ore transportation center twelve miles south of the Delaware Water Gap. At this junction, along the high embankments, the Pennsylvania and Lackawanna Railroads join to run along the same narrow track. The Manunka Chunk Road will bring you to Belvidere, the Warren County seat. It is a beautiful spot where the Pequest River flows into the Delaware. Town Square, in the center of the hilly and prosperous town, has a stand of splendid old-growth trees. In colonial times it was known as Greenwich-on-the-Delaware, and its avenues and buildings were laid out to incorporate the natural environment. By nature and design Belvidere is a restful and peaceful place, ideal for a stroll.

Island Park on the Pequest River, just west of the junction of U.S. Highway 46 and State Highway Route 31, is known as a fisherman's paradise where anglers catch brown and rainbow trout. Hot Dog Johnny's is a famous

ROUTE 3

From Manunka Chunk, take U.S. Highway 46 south to Manunka Chunk Road, which runs southwest to Belvidere. From Belvidere, take County Route 620 north to U.S. 46, which runs east to Buttzville. Go left (north) on Greenpond Road and right (east) on Mountain Lake Road (County Route 617). Make a left turn off Mountain Lake Road onto Lake Just-It Road and a right turn onto Hissim Road, which runs north to Hope–Great Meadows Road (County Route 611). Follow County Route 611 west and north to Hope. Take Hope–Blairstown Road (County Route 521) north to Blairstown. Drive north on Stillwater Road and continue north on West Shore Drive (still County Route 521). Turn right on County Route 622, which runs through Swartswood State Park. Cross Paulins Kill Lake and continue on County Route 622 east to Newton. From there, follow Ridge Road (County Route 519) south to Whittingham Wildlife Management Area, or U.S. Highway 206 south to Kittatinny Valley State Park.

RIGHT: *Located on an unpaved portion of the Old Mine Road along the Delaware River, the Van Campen Inn was a favorite stopover for Benjamin Franklin.*

BELOW: *The tight folds of ridge and valley country are part of the Great Valley of the Appalachians, and columbine blooms in abundance on the area's limestone outcrops.*

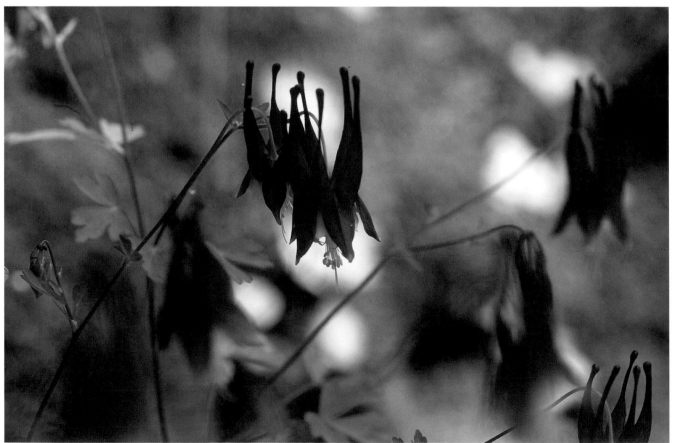

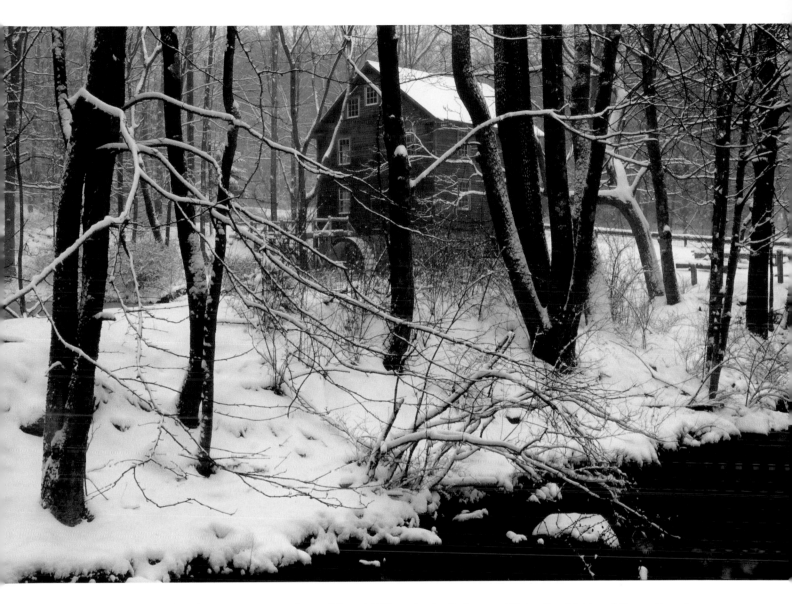

The Garis gristmill has been reconstructed at Millbrook Village in the Delaware Water Gap National Recreation Area.

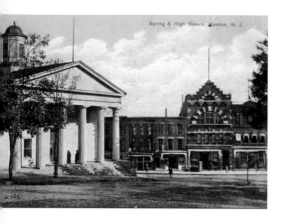

This vintage postcard illustrates the view of Spring and High Streets in Newton, the county seat of Sussex County.

landmark, here since 1935 and still going strong on U.S. 46 "at the light" in Buttzville. Drivers stop to enjoy a hot dog in a steaming-hot bun, wrapped in wax paper and served with a glass of farm-fresh buttermilk, while sitting at a picnic table where they can gaze at the rippling waters of the Pequest River rushing by.

When the Wisconsin ice age retreated from this region of New Jersey about twenty thousand years ago and began to melt, it left behind huge moraines and ground-out valleys. The rolling terrain in Jenny Jump State Forest, a 4,271-acre two-part park, offers panoramic vistas of the highlands and the Kittatinny Mountain ridge and valley to the west and scenic views of the Great Meadows to the east. As for the name Jenny Jump, legend says that a band of Lenape Indians came across a settler and his daughter picking berries, and the father screamed, "Jump, Jenny, jump!" To save herself from the rampaging tribe the nine-year-old girl ran and, following her father's command, jumped off a cliff. Some versions of the legend, which originated in 1747 in a record by Swedish missionary Sven Roseen, say that the poor girl died; others say that she survived the terrible fall. Whether true or not, the story and the myth continue to persist in these parts.

Hope is home to Land of Make Believe children's theme park on the Hope–Great Meadows Road, nestled in the foothills of the Jenny Jump Mountains. This thirty-acre amusement park is a place for an action-packed day of family fun for parents and children (but mostly for young children) featuring a buccaneer pirate ship, a Civil War locomotive train-ride, old McDonald's farm, an enchanted Christmas village, a haunted Halloween house, and a family picnic area to rest up after all this amusement.

Quaint and charming Blairstown on the eastern slope of Kittatinny Mountain and in Paulins Kill Valley is the home of Blair Academy, a notable preparatory school, and many architectural treasures are to be seen in the mixture of academy, residential, and farm buildings throughout the town.

Northwest of historic Blairstown is the Mohican Outdoor Center. To get there from Blairstown center, take State Highway Route 94 one mile south; make a right on Mohican Road, a left on Gaisler Road, and a right on Camp Road. Nestled in the Kittatinny Mountains, alongside the Appalachian Trail in the eastern section of the Delaware Water Gap National Recreation Area, the center is surrounded by seventy thousand acres of wilderness. It is run by the Appalachian Mountain Club in partnership with the National Park Service and offers a place for weary hikers to assemble (around the fireplace at the lodge), with camping, a bunkroom, and cabins available.

Farther along, pass through Stillwater and Middleville to Swartswood State Park's 2,250 acres of woods, lakes, and ponds. Little Swartswood Lake is to the north; in the southern section of the park, Swartswood Lake—the big one—is considered to be one of the best trout-stocked lakes in the state for fishing.

County seat of Sussex County and a major conduit for traffic north and west, Newton has many historic structures, including the newly restored landmark county courthouse, built on top of a steep hill in 1847, and the downtown shopping area with its preserved nineteenth-century shops. The Newton Fire

Museum at 150 Spring Street has a collection of local memorabilia and an impressive array of early firefighting vehicles, which includes hand-drawn hose carts, ladder wagons, a hand pumper from 1863, and a steamer from 1873. Check out the Merriam House at 131 Main Street for its Queen Anne architecture.

If this is too much city life for you, the 1,800-acre Whittingham Wildlife Management Area is two miles south and has a 400-acre natural area, which is home to rare waterfowl, black bear, beaver, otter, and other wildlife. In nearby Kittatinny Valley State Park the freshwater ponds and lakes provide perfect habitat for a great many birds, including woodpeckers, bluebirds, swallows, purple martins, cardinals, red-winged blackbirds, robin red breasts, and chestnut-sided warblers. Located on the Atlantic flyway, bird watching is prime at this watery spot; sightings might include hawks, owls, and migratory ducks as well.

THE PLACE WITHIN THE HILLS
THE ALLAMUCHY MOUNTAINS
AND LAKE HOPATCONG

New Jersey is replete with many different kinds of "wild lands." Wild West City, south of Andover, is called the "Best of the West in the Heart of the East." In the eighteenth century, New Jersey *was* the Wild West, and it all comes to life here with lots of fun for everybody in this Western heritage theme park. The best things to do at Wild West City are watch the reenactment of the gunfight at the OK Corral, have a Western-style barbecue lunch, and enjoy a Western stage show at the Golden Nugget Saloon. If you are a train lover, take a trip on an old Jersey-made antique locomotive; there are also stagecoach and pony rides. Ride 'em cowboy!

The drive along the Musconetcong River through Allamuchy Mountain State Park is beautiful. The Lenape lived in this area for twelve thousand years until they were pushed west by the colonial settlers, vanishing entirely by 1743. Allamuchy Mountain State Park is mostly undeveloped, but within its eight thousand acres lies Waterloo Village, a National Historic Site that is the epitome of a mid-nineteenth century manufacturing town. Iron ore from the Andover Iron Works was processed here in four fire furnaces with two hammer forges. In 1831 the Morris Canal made Waterloo an important inland port, connecting the Sussex Railroad with the Morris & Essex Railroad. The canal ceased operation, however, and around the turn of the twentieth century the railroad bypassed the town, which then became a quiet residential hamlet forgotten by time. You can look inside the stagecoach inn and the restored blacksmith shop, stroll along the banks of the Morris Canal locks, and see inclined planes as they were in 1880. Regular demonstrations of traditional trades and crafts include spinning, weaving, broom making, gunsmithing, potting, and basket making, practiced by the artisans. On Winakung Island there is a re-created Lenape Village with longhouses, demonstrating the culture and lifestyles of the Lenni Lenape in 1625. There has been some question regarding the future of Waterloo Village, but as of this writing, the state plans to keep the site open for years to come.

ROUTE 4

From Andover, drive south on U.S. Highway 206 and turn left onto Lackawanna Drive (County Route 607) to reach Wild West City. Return to U.S. 206 and continue south. Make a right turn onto Waterloo Road (County Route 604) south to reach Waterloo Village. Drive back to U.S. 206 and continue south to connect with State Highway Route 183 east, to Brooklyn Road (County Route 602) north and east. Continue north on Lakeside Boulevard (County Route 607), which becomes River Styx Road. Continue west on Maxim Drive (still County Route 607). Make a right turn (north) onto Stanhope-Sparta Road (County Route 605), which runs to Sparta and Lake Mohawk.

Lake Hopatcong was known as "the Jewel of the Mountains" when grand hotels lined its shores a century ago. Today, it is within the lake-studded region covered by the 2004 Highlands Water Protection and Planning Act, which seeks to protect the water supplies of more than half of the state's residents.

Hopatcong State Park is located at the outlet of Lake Hopatcong, which is the largest lake in the state, covering 2,685 acres. It was enlarged as part of the Morris Canal, which crossed Lake Musconetcong in Stanhope with the aid of an earthen dike for the towpath. At more than nine hundred feet above sea level, the lake was the major water supply for the canal at its summit. The Lake Hopatcong Historical Museum, located near the dam, is in a nine-room 1825 restored structure, which was the home of the canal lock-keeper. It has exhibitions and artifacts of the old canal days and of the Lenni Lenape. Have a picnic, a swim, or just enjoy the breeze and take in the splendid lake views.

Across the other side is Bertrand Island (actually a peninsula), where once stood Bertrand Island Amusement Park. The site closed in the 1980s, but it was a legendary, mystical place with a famous wooden roller coaster that careened right over the lake; an aeroplane ride; an ancient, wood-carved, hand-painted merry-go-round; a penny arcade; and other delights. A 1920s Art Deco ballroom was a part of the mystique of this park set on the east side of Lake Hopatcong. Woody Allen made *The Purple Rose of Cairo* here, which starred Mia Farrow, Jeff Daniels, and Danny Aiello.

As you drive north on Lakeside Boulevard, imagine the grand hotels that once dotted the ridge above you with their great lawns sweeping to the lake. Boathouses, some with their origins in those days, still line the shore. Lake Hopatcong, fed by nine rivers and streams and hundreds of springs gushing from the floor of the valley, supports the greatest number of pleasure craft of any inland body of water, so watch out for speedboats on this big lake. Attend the races, or a regatta.

During the roaring twenties a six-hundred-foot dam was built at the headwaters of the Wallkill River, creating attractive Lake Mohawk. In 1928 real-estate developer Arthur Crane built a rustic, twenty-five-hundred-acre resort on the ten miles of wooded, rocky slope with alpine, log cabin, colonial, ranch, split-level, and Adirondack-style lakeside homes. Visit the historic district's shops and restaurants, all in their unique, fanciful "Lake Mohawk Tudor" architectural style. Get an ice cream cone and sit on a nearby boardwalk bench overlooking the lake. So successful was this private resort community that similar developments were built in the state after World War II at Lakes Saginaw, Seneca, Shawnee, Summit, and Winona.

COLONIAL TOWNS OF THE AMERICAN REVOLUTION
MADISON, MORRISTOWN, AND MORE

A natural ridge leads from a gap in the Watchung Mountains to the north and west upon which the Lenape's Minisink Trail would eventually reach the Delaware River. Later, Kings Road and Morris Turnpike brought produce to market in the other direction. And in 1837, a railroad was completed that encouraged development and attracted families. Where rural countryside and

ROUTE 5

From Madison, follow State Highway Route 124 east to Chatham and turn right on Fairmount Avenue (County Route 638). Turn right onto Meyersville Road. In Meyersville, turn right on New Vernon Road (County Route 604) to White Bridge Road and the Raptor Trust. Backtrack and make a left turn on New Vernon Road, which becomes Long Hill Road. Turn right on Lee's Hill Road (County Route 663), left on Glen Alpin Road (County Route 646), which crosses U.S. Highway 202, and onto Tempe Wick Road. Follow Jockey Hollow Road north onto Western Avenue into Morristown. Take Washington Street (County Route 510) west to Chester, then follow Washington Turnpike (County Route 513) west to Cooper Mill and State Park Road south. Turn right on Hacklebarney Road and right on Black River Road to Fairmount Road (County Route 517) north to Long Valley. Go over the bridge and follow Schooley's Mountain Road (County Route 517) north to Hackettstown.

the city merge, the Morris & Essex Line created one of the first railroad suburbs, and the stretch of road between the towns of Madison and Morristown became known as "Millionaire's Row."

Today the charming town of Madison is filled with interesting shops, like Betty Moore's Time After Time Vintage Clothing on Main Street. Home of Drew University, a Methodist college with splendid, neo-classic, Greek Revival architecture, Madison was the center of the commercial rose-growing industry and, from 1900 to 1950, was called the "Rose City." The Museum of Early Trades and Crafts, housed in a beautiful building originally constructed as the town library in 1900, is dedicated to the tools and methods of early nineteenth-century craftsmen. In its vaulted halls is a collection of over eight thousand artifacts related to twenty-one different trades. (Along your route, you will pass the town of Chatham, which is similar to Madison with its small shops and quaint side streets.)

Meyersville Road traverses the circular ridge of the Great Swamp National Wildlife Refuge, a 7,400-acre site teeming with deer, beaver, river otter, muskrat, mink, red fox, coyote, woodchuck, bog turtles, salamanders, and other wildlife. The terrain includes swamp, marshland, brooks, streams, still waters, and—on higher ground—hardwood forests and open fields. The refuge was established in 1960 and headquarters is on Pleasant Plains Road. Here you will learn that more than 222 different bird varieties have been sighted in the swamp, which—in prehistoric times, about 25,000 years ago— was a giant lake filled by the retreating Wisconsin Glacier. The 3,600-acre core of the swamp was designated by Congress in 1968 as a National Wilderness Area on Department of Interior lands. No permanent structures, vehicles, equipment, or even bicycles are permitted. The western half of the refuge is intensively managed to maintain optimum habitat.

Contiguous to the Great Swamp is the Raptor Trust. This zoolike bird sanctuary is set in a beautiful wooded area where a great many birds of prey are housed in enormous outdoor cages, as a result of some kind of injury or because they were orphaned. The birds are rehabilitated and possibly released back into the wild. Visitors are welcome to view face to face the wonderful owls, falcons, and hawks of every distinction, as well as bald and golden eagles. Some of the owls in recuperation are huge with swiveling, bigger-than-human heads, while other owls can be as tiny as pigeons.

Morristown National Historical Park, the nation's first, was created in 1933. It includes four parcels of land: Ford Mansion, Fort Nonsense, the Jockey Hollow Encampment Area, and the New Jersey Brigade Encampment Area. A highlight of the Jockey Hollow area, the largest of the parcels, is the Wick House and farm. The road through Jockey Hollow passes through the encampments of Washington's troops. When the National Park Service took over in the 1930s, Franklin Roosevelt's Civilian Conservation Corps (CCC), Works Progress Administration (WPA), and other New Deal programs were employed in restoration projects, such as rebuilding the soldiers' huts in the hollows along the hilly, winding road. It is difficult to imagine the ten

Countless historic gems can be found in Morristown, as seen in these vintage postcards depicting the home of famed Revolutionary War figure Tempe Wick and the kitchen fireplace at George Washington's headquarters.

RIGHT: *Horse farms line the road in Pottersville, Peapack, Far Hills, and Oldwick, and jodphurs mix in the lunch line at the general store.*

BELOW: *At the Essex Hunt Club fox trials, there's no fox, but there are hounds and rustic fences to jump in the rolling fields.*

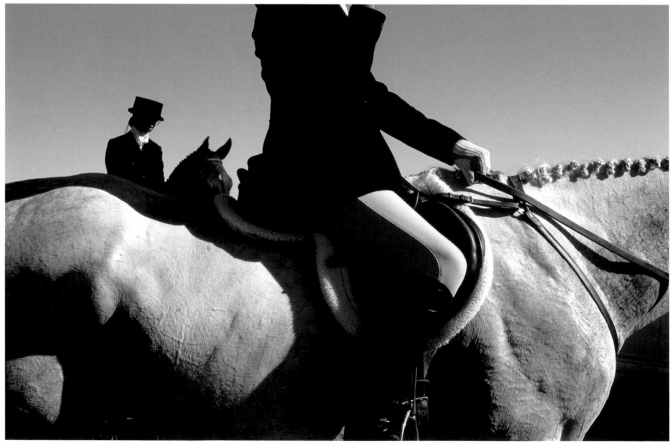

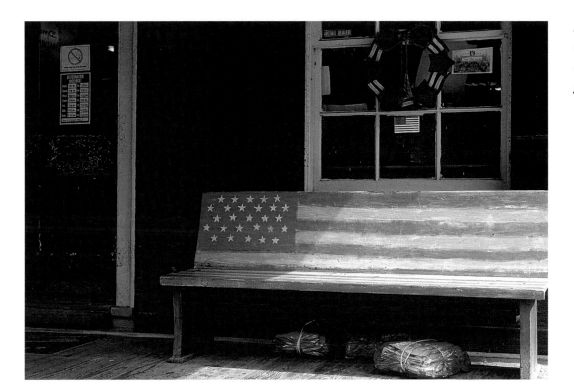

A patriotic reading bench sits outside the Schooley's Mountain general store.

The desperation of the men of the Continental Army encamped in Jockey Hollow during the fiercely cold and stormy winter of 1779–1780 was so great that, for a short time, the Pennsylvania Line mutinied. They began by breaking into a powder magazine in this orchard of the Wick Farm.

thousand soldiers encamped in these cold valleys during the most severe winter of the Revolutionary War (1779–1780).

Another feature of the Jockey Hollow area is the Tempe Wick Garden, an authentic colonial garden that originated in its present-day form in the mid-eighteenth century. During the Revolution, Tempe Wick secreted the last family horse in the bedroom of her tiny house for three weeks, keeping it from the British redcoats and turncoat militiamen, the Continental Army, and even Washington's troops—all desperately in need of any horse they could get their hands on. The horse story became legend and Tempe Wick herself a celebrated character. The historic garden features pale blue flowering flax to make linens; white flowering soapwort for washing wool items, utensils, and farm equipment; quince and gooseberry bushes; currant shrubs; vines of scarlet runner beans; medicinal herbs; kitchen herbs for spices and teas; and more. The house and land—with its dirt paths, rolling fields, and forested hills—is a bucolic setting strongly emoting the past.

In Morristown, this most historic of American towns, there are many sites to be seen. Start a downtown tour in the Morristown Green; nearby historic sites include the Schuyler-Hamilton House at 5 Olyphant Place, a clapboard colonial home restored with period furnishings and maintained by the Daughters of the American Revolution. Alexander Hamilton, with Washington during the Revolution, courted and was engaged to a young woman who lived here. Built in the 1860s, Villa Fontana, at 50 Macculloch Avenue, was the home of famed cartoonist Thomas Nast and is now a national historic landmark. Nast created the Republican elephant and Democratic donkey as party symbols, and he invented the look of Uncle Sam in striped trousers and red, white, and blue top hat.

The Palladian style popular in England at the time was employed by Colonel Jacob Ford Jr. for his mansion, which served as General Washington's headquarters in his second stay in Morristown during the winter of 1779–1780. The Ford Mansion, built in 1774, was re-plastered at the general's own expense after Mrs. Theodosia Ford, widowed during the war, refused payment. The house had been the scene of many balls given by Martha Washington to keep up the morale of the Continental Army. A hundred years after the war, some prosperous Morristown businessmen founded the Washington Association of New Jersey and purchased the Ford Mansion at auction.

For almost another hundred years they collected and preserved mementos and maintained the house and lands, until the City of Morristown granted title of the historic buildings and sites to the National Park Service. At the formal dedication of Morristown National Historical Park on July 4, 1933, President Franklin D. Roosevelt declared Ford Mansion as "our first White House," while Secretary of the Interior Harold L. Ickes praised Washington's genius "in selecting these hills as his military headquarters, difficult of access as they were to the foe, yet for the revolutionary commander within easy striking distance of two vital cities, New York and

Philadelphia." The National Park Service restored the Ford Mansion and constructed a nearby museum and interpretive center featuring maps and displays pertaining to the American Revolution.

Two narrow trails crossed in the wooded rolling hills at *Alamatuck*, or "black earth bottom," when the earliest settlers arrived. But the area next to Black River eventually flourished with gristmills, sawmills, and distilleries, and in 1779 it was officially established as the Township of Chester. Today, Chester is a bustling crafts and antiques center with dozens of shops and more than a dozen restaurants.

The drive to Hacklebarney State Park is partly farmland but mostly woods, much of it part of the Black River Wildlife Management Area and the Black River County Park. Rocky streams, deep ravines, rustic picnic tables, and fireplaces are part of the wonder of this great natural setting. At Cooper Mill, visitors can see the two-thousand-pound mill stones still in operation.

In the small farm community of Long Valley, a historic cemetery and German church can be found alongside the south branch of the Raritan River, which flows quietly through the center of the valley and past farms and little villages. The way over Schooley's Mountain is twisted and steep; the mountain's healing mineral waters were once the main attraction, but now an authentic general store sits alone by the road. In the 1880s Hackettstown was a major carriage-building center, and today M&M Mars manufactures candy in the bustling valley crossroads.

FOOD FOR THOUGHT

For a local-history refresher course with food and drink, visit the Minuteman Family Restaurant on Mt. Kemble Avenue, off of U.S. Highway 202, south of Morristown center. Old fashioned and covered in knotty pine, this unpretentious and inexpensive place features a James Madison hamburger and offers an Old English cheeseburger called the Nathan Hale. Other burger combos and sandwiches include the John Hancock, Tom Paine, and Thomas Jefferson. The pies and other home-baked goods are delicious. If only this cozy place had been in business during the American Revolution, the cold and hungry Continental Army regulars could have marched over from Jockey Hollow for coffee and donuts.

Another culinary treasure on Mt. Kemble Avenue is Wightman's Farms. This 145-acre family farm was established by Laetitia and Albert Wightman in 1922.

Albert planted fruit trees and vegetables to sell in Morristown. Eventually, motorists from town came out to the farm to buy fruit and vegetables at a table across the road from today's marketplace and cider mill. Generations have carried on, and the Wightman family still continues, the tradition of selling the produce grown on the surrounding farm. The cider press offers freshly squeezed cider made from the family's own special blend of apples; and it has a delicious, cherry cider, good to sip while looking over the 120 kinds of fruit and vegetables available: summer tomatoes and corn, fall squash and pumpkins, and everything else in between. Wightman's specialties include smoked bacon, jam preserves, and home-baked pies. It offers farm tours and hayrides in September and October; a special time to visit is Halloween for pumpkin harvest.

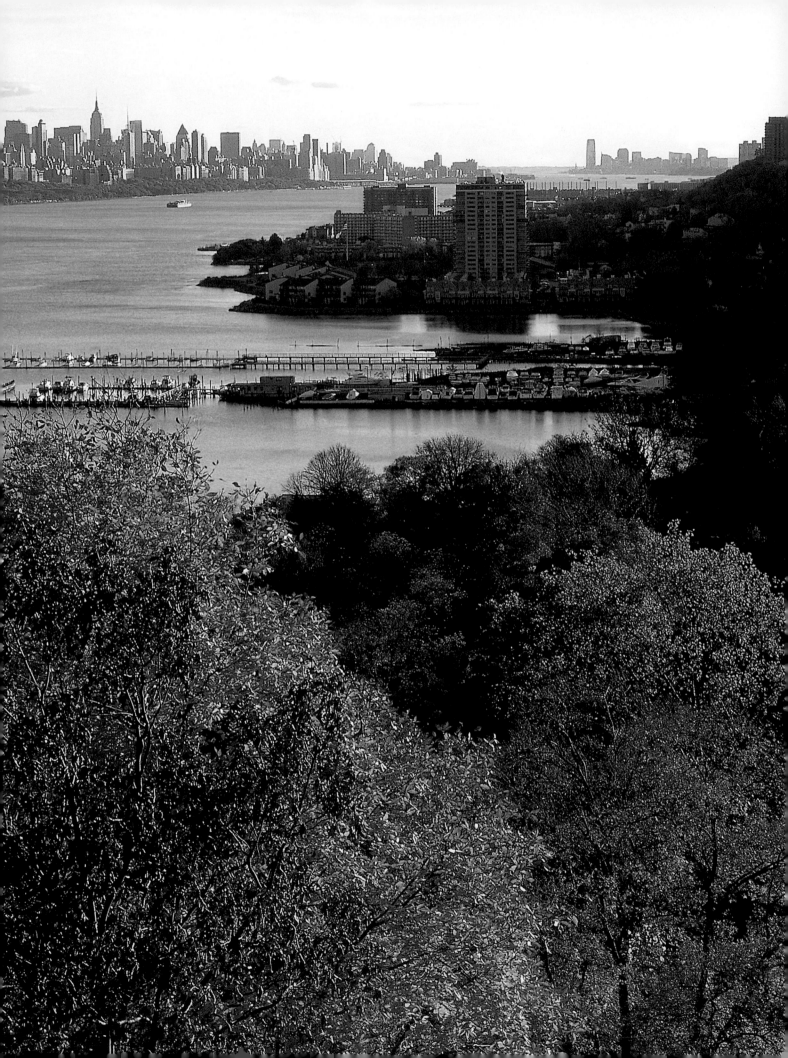

THE GATEWAY REGION
CITIES, SUBURBS, AND JERSEY DINERS

ABOVE:

The 1950s live on in a restored Ford Edsel at a Lyndhurst car meet.

FACING PAGE:

The Fort Lee Historic Park preserves the earthen ramparts above the Hudson River.

New Jersey has the greatest population density of any state, and near the Hudson River that density is at its greatest. How then a backroad? Simply, when a new road is built, the older road is usually less used to travel through the area, but rather to travel within it. The by-passed road thus becomes a backroad. The leisurely drive may be more difficult, but it can be as rewarding. Where the layers of roadway are thickest, so too are the history and the sights that are most truly unique. For this state, then, a backroad could be about anything off the New Jersey Turnpike. As the in-joke goes: "What exit?" The answer: all of them.

HUDSON RIVER VIEWS
FROM THE PALISADES TO HOBOKEN

ROUTE 6

From the State Line Lookout off the Palisades Interstate Parkway north, return to the parkway, then reverse direction to Exit 2. Go left under the Palisades Interstate Parkway and down the cliff to take Henry Hudson Drive south, passing under the George Washington Bridge, to River Road (County Route 505). Drive south then up the cliff at Hillside Road, left on Boulevard East, and left onto Hamilton Avenue in Weehawken. Return to Boulevard East going north, and take a right on Pershing Road descending south to Port Imperial Boulevard over the Lincoln Tunnel, left to follow Harbor Boulevard onto Park Avenue, left on 14th Street, and right onto Washington Street in Hoboken.

When Henry Hudson sailed up the Hudson River in 1609 he declared it sparkling and alive with fish and awesome in its breadth and beauty. He called the land "the finest for cultivation that ever in my life I set foot on." The New Jersey side of the mighty river is bordered by the towering crags of the Palisades, vertical cliffs of rugged basalt magma that were thrust up by tectonic activity and then eroded for over two hundred million years. Jutting up and forming a natural boundary between the two states, the jagged cliffs gradually descend from a height of 547 feet at New Jersey's northeastern border to a few outcroppings no higher than 40 feet down along the shores of Lower New York Bay. Behind the Palisades lies the most densely populated multiple municipalities in the country.

Declared a National Historic Landmark in 1965, Palisades Interstate Park was created in 1900 to halt the destruction of the unique cliffs by ongoing rock quarrying. The park is run by ten commissioners, five from each state, appointed by the states' governors. The New Jersey section makes up 2,419 acres of the 10,358-acre park, and some of the best views in the region are off the Palisades Interstate Parkway. The nearby Tenafly Nature Center, located just west of this route, is a heavily forested fifty-acre preserve created primarily for local people to enjoy a touch of the wild lands the early settlers displaced.

Perched atop the Palisades, Weehawken is a close-knit community directly across the river from the Empire State Building in Manhattan. The little city is bordered by Union City to the west, West New York to the north, and Hoboken to the south. The King Estate in Weehawken was the site of the historic duel between Alexander Hamilton and Aaron Burr on July 11, 1804. Bitter enemies from opposing parties, the former Secretary of the Treasury Hamilton had insulted then–Vice President Burr, who challenged him to a fight to the death. That fateful morning they rowed across the river from Manhattan to Weehawken Heights, where Burr shot Hamilton in the stomach. They hustled Burr out of the area and Hamilton was rowed back to New York, where he died the next afternoon. An early monument commemorating the site was destroyed by citizens protesting the practice of dueling. The monument today, on Hamilton Avenue, features a bust

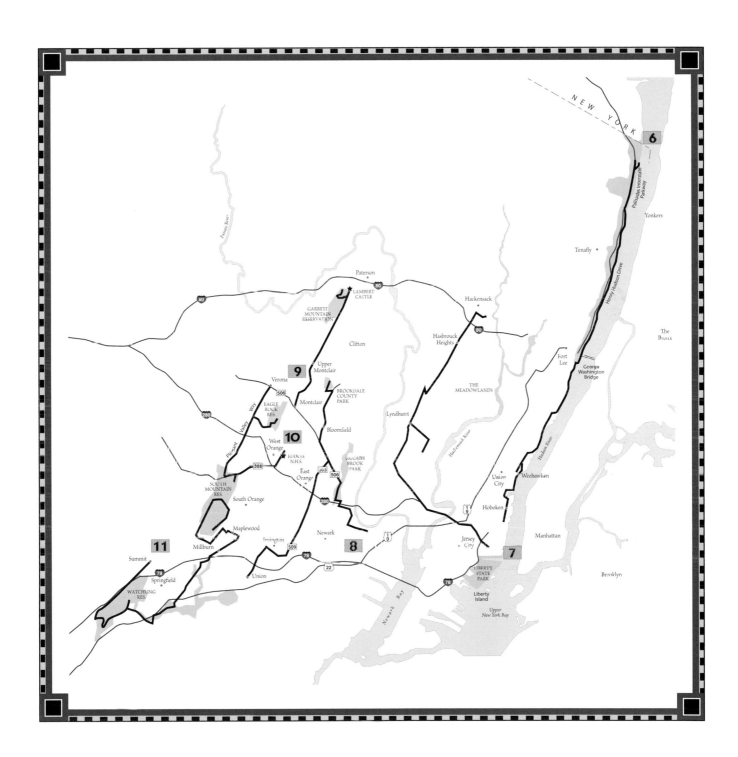

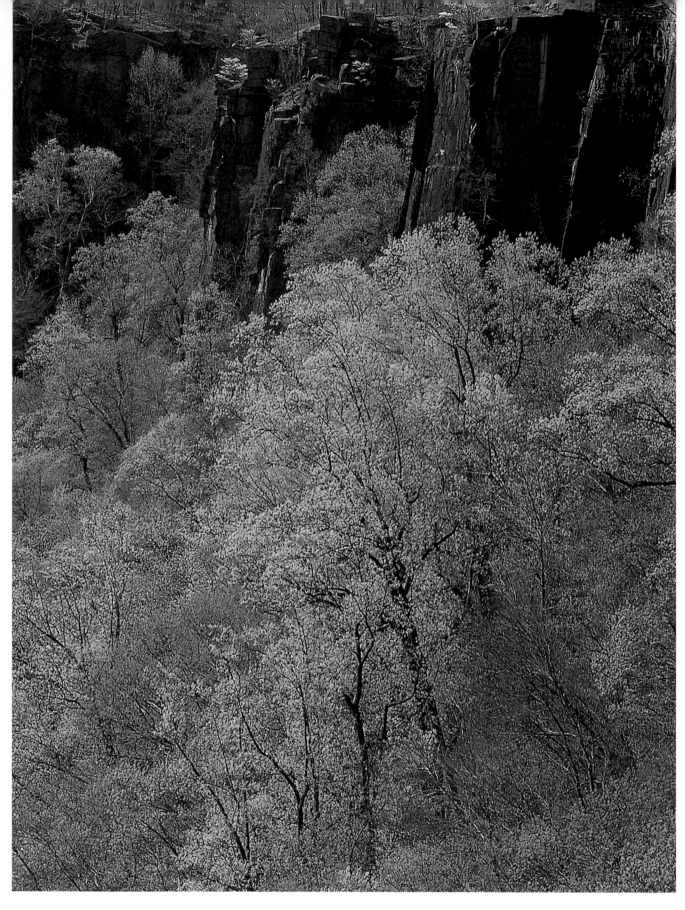

Vertical columns of ancient basalt have weathered to a fine old craggy appearance in the Palisades. Nearby, a small tower commemorates the New Jersey Federation of Women's Clubs and their efforts to preserve these cliffs on the Hudson River.

Dutchman's breeches grows profusely below the Palisades cliffs. In 1609, Henry Hudson and the first mate of the Half Moon, *seeking the elusive northern passage to the Far East for the Dutch East India Company, were the first Europeans to record an exploration to the headwaters of the river.*

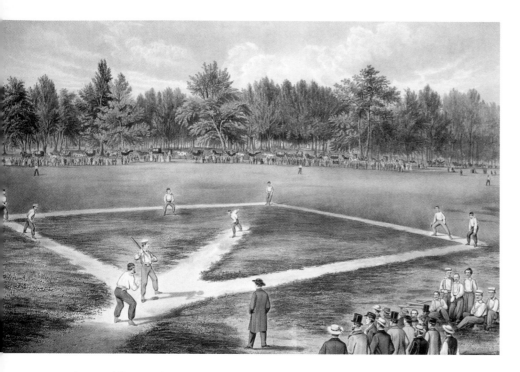

The world's very first organized baseball game was played at Elysian Fields in Hoboken, New Jersey, in 1846. A classic Currier and Ives print depicts the grand match for the championship at Elysian Fields.

of young Alexander Hamilton, which sits on a stone. The plaque says it is the "very stone on which lay his head when he fell."

Between the Lincoln and the Holland Tunnels is the attractive, historic, mile-square city of Hoboken, set on land that was once a tidal swamp just below the cliffs of Jersey City. Jersey City Heights is to the west, and a high ridge on the Hudson, where Stevens Institute of Technology is located, is the town's eastern border. On campus at Castle Point, sightseers can take in the most direct panoramic view of the Hudson River and the Manhattan skyline to be seen anywhere. Truly a wonder to behold! The view extends from the south at the Verrazano-Narrows Bridge—a link between Brooklyn and Staten Island—to the north at the George Washington Bridge, one of the major connections between New Jersey and New York.

The land of *Hobocan Hackingh*, archaic Dutch meaning "Land of the Tobacco Pipe," is best explored on foot. To "walk the walk" you must first park the car; drive downtown on Hoboken's main thoroughfare—Washington Street—where you'll find several parking lots. An impressive sight on the Hudson River waterfront, a couple blocks from the end of Washington Street, is the historic Erie-Lackawanna Railroad Station. Presently the Hoboken Terminal for NJ Transit, this copper-clad national landmark with an outstanding Beaux Arts façade and a newly restored interior topped by a gigantic, Tiffany stained-glass ceiling is a busy commuter station. Swift-moving ferries also cross the river to New York City from the south end of the train station.

A walk up Washington Street offers many restaurants, shops, and sights, including the 1881 Hoboken City Hall at Washington and First Streets and the John Jacob Astor house at 128–133 Washington Street. Astor, a fur trader and the wealthiest American of his time, often entertained literary friends such as Washington Irving here at his summer villa. At 134 Washington Street, Johnny Rockets, a 1950s-style hamburger palace, is the place where the sandwiches, chili, French fries, and malteds are served up by waiters who dance and sing along with 1950s hits on the jukebox. Another spot along the way is Benny Tudino's at 622 Washington Street, which since 1968 has claimed to sell "the largest slice" of pizza in the state—and this may well be the truth. A noted rock club called Maxwell's is at 1039 Washington Street at 11th Street, and Helmers' Restaurant, with its high paneled wooden booths and German cuisine, is a mainstay at 1036

Washington Street. Just across the street from Helmers' is a plaque that commemorates the famous Elysian Fields baseball game. Hoboken historian Jim Hans has authenticated that the world's first organized baseball game took place here on June 19, 1846.

Frank Sinatra, who was born in Hoboken in 1915, lived at 415 Monroe Street where there is a gate in front of an empty lot; this is where the Sinatra family home once stood. Supposedly Sinatra had the actual house torn down so gawkers and fans could not see his early beginning in the poor, Italian neighborhood. In Hoboken today, images of "the Voice" abound in store windows, and there is a road along the waterfront called Frank Sinatra Drive that passes by Frank Sinatra Park. The Hoboken Historical

PALISADES AMUSEMENT PARK MEMORIES

A thirty-eight-acre picnic grounds on the New Jersey Palisades, with its scenic view of the Hudson River and Manhattan, became Palisades Amusement Park in 1898. This is a place of legend never to be forgotten by those who were there. It was partly in Fort Lee, Cliffside Park, and Edgewater, though not in nearby suburban Palisades Park.

Attractions through the years ranged from turn-of-the-century diving horses to 1950s and 1960s rock 'n' roll extravaganzas. A super funhouse, a merry-go-round, and a terror-filled roller-coaster ride known as the Cyclone brought in devotees from the entire tri-state area. Owners Nicholas and Joseph Schenck, who had vaudeville and movie connections, built a mammoth salt-water swimming pool with a white sand beach, constructed a miniature golf course, and held Diaper Derby events, as well as Little Miss America and Miss American Teenager contests. Headliners in the big entertainment arena included Cab Calloway, Benny Goodman, Tony Bennett, Chubby Checker, and scores of other all-time greats. Belgian waffles, Harry's Hamburgers, and Paul's Clam Chowder stands were memorable food attractions. The park closed in 1971 due to a lack of attendance, which the owners blamed on television and changing times.

Roller coasters and other attractions brought fun-seekers in droves to Palisades Amusement Park during its glory days. The park was in operation from 1898 to 1971.

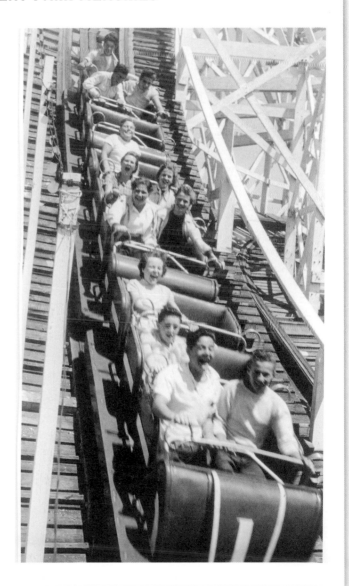

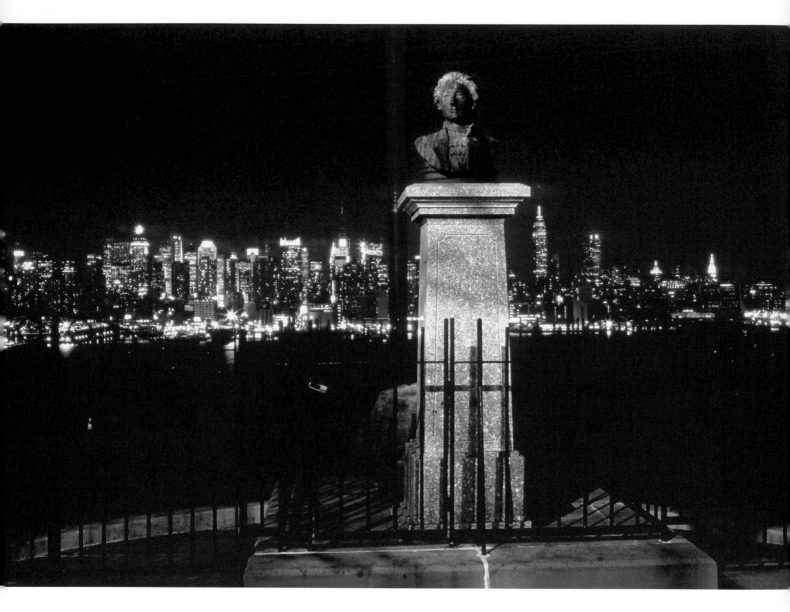

In 1804, politics was personal as Aaron Burr and Alexander Hamilton dueled on a bluff below this spot. Burr won. On the 200th anniversary of the famous duel, the principals' family associations held their first joint meeting.

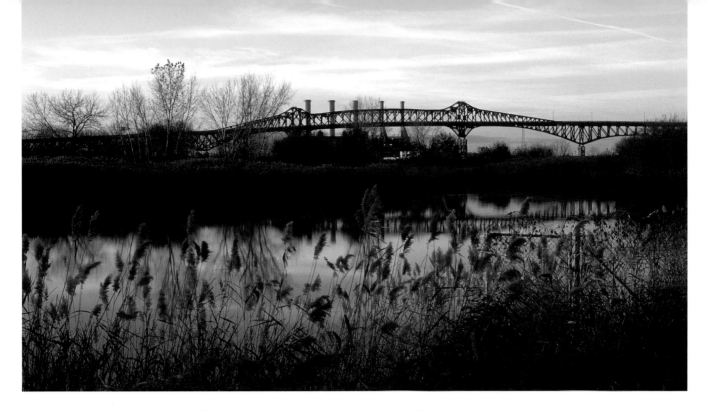

Until recently known as simply "the Swamp," the Meadowlands is an excellent area for bird watching.

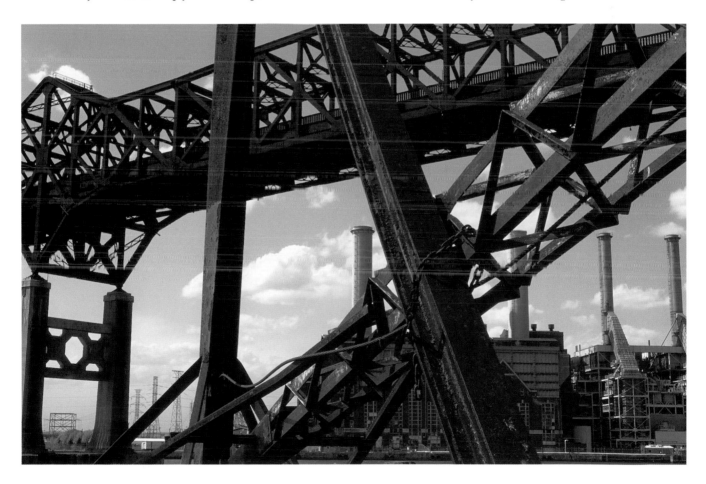

The Pulaski Skyway opened in 1932 with the accolade of "Most Beautiful Steel Structure." The main spans consist of cantilever steel through Pratt trusses that support flanking suspended spans high above the Hackensack and Passaic Rivers.

Museum often features Sinatra events and paintings of "Old Blue-Eyes," and there is also a Frank Sinatra Museum, where a collection of Sinatra memorabilia is permanently on view.

Today the streets of Hoboken, with their historic nineteenth-century, four-story, brick-face and brownstone buildings, seem like an extension of Greenwich Village; and the real estate values and rentals rival those in pricey Manhattan. Once a town noted for shipping and factories like My-T-Fine Pudding Company, Cocomalt, the Log Cabin Syrup Company, and Maxwell House Coffee, Hoboken now has condominiums and cooperatives steadily popping up everywhere. Although no longer a dock-worker-on-the-waterfront kind of a town, Hoboken has not lost a bit of its charm.

THE DINER QUEST
THROUGH THE MEADOWLANDS

ROUTE 7

Explore Jersey City and Liberty State Park. Head west out of Jersey City on the Belleville Turnpike, and make a right turn on Schuyler Avenue to Orient Way, which runs north to Lyndhurst. Take a right on Valley Brook Avenue to the Meadowlands Environment Center, then return to continue on Orient Way to Rutherford. Go right on East Erie Avenue and left on Hackensack Street, which becomes Terrace Avenue, to Hasbrouck Heights. From Hasbrouck Heights continue north on Polifly Road, and right on Essex Street to Hackensack.

If the prevailing impression of the state is what you see of its industrial core as you bypass New York City on the New Jersey Turnpike, then this may be the ultimate New Jersey "backroad" adventure. Explore the meat and muscle that make a city work. Among the bulrush may lie the most hidden gems. Jersey City is the state's second largest city, after Newark. The Grove Street area, with a skyline rivaling Manhattan's, sits on the edge of New York Bay and directly across from lower Manhattan. Farther south along the harbor is Liberty State Park, and just off the Jersey shoreline is Ellis Island and Liberty Island, where the Statue of Liberty stands.

In the northern section of Liberty State Park is the Liberty Science Center, one of the state of New Jersey's most visited places, dedicated to the exploration of nature, humanity, and technology. Audrey Zapp Drive is a two-lane, cobble-stoned delight of a road, stretching east straight to the harbor. On your right is the Central Railroad of New Jersey terminal, the brilliantly restored crown jewel of the park. Along the road and at the end, the views of lower Manhattan, New York Harbor, Ellis Island, and the Statue of Liberty are—as one resident put it—surreal. To add to the scene, just north of the Morris Canal Basin in Jersey City is the restored, colossal, neon Colgate Clock. Take Freedom Way south or walk the two-mile Liberty Walk Promenade through a thirty-six-acre natural area river marsh.

New Jersey has been called "Diner Country" by cultists in search of the perfect diner, with original 1930s, 1940s, or 1950s design and great American specials like ham and eggs with home fries or hamburgers with French fries and coleslaw. The Miss America Diner at 322 West Side Avenue (almost at the border of Bayonne) in Jersey City is one of the ultimate, original 1950s diners to be found anywhere in the world. Its stainless steel and red-and-blue neon exterior greets local workers, truckers, students, and diner aficionados into its Formica and gray-and-peach interior for the very best in diner-fare.

You may also want to visit the White Mana Diner, just north of Journal Square on Tonnele Avenue (U.S. Highway 1-9), also in Jersey City. This is a busy truck route, so instead take John F. Kennedy Boulevard north from the Miss America Diner through Journal Square to the Heights. At Manhattan Avenue make a left turn. Leonard J. Gordon Park offers splendid western views of the industrial and natural meadowlands and the two great rivers—the Hackensack and Passaic—that run through them. At

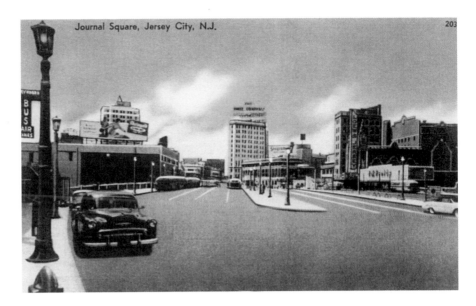

the bottom of the hill you will find the White Mana right smack on busy U.S. 1-9. The futuristic-looking building was originally on display at the 1939 New York World's Fair in Queens, New York.

Journal Square, in the center of Jersey City, is a major transportation hub, linking bus lines and the Port Authority Trans-Hudson (PATH) train system to Newark and New York. It is home to two historic movie palaces from filmdom's glory days, the Stanley Theater (now an Assembly Hall of the Jehovah's Witnesses) and the Loew's Jersey Theatre, both built in 1928. There are architectural tours of the six-thousand-seat Stanley, and events at the Loew's include showings of classic movies on the big screen.

The meadowlands lie to the west of Jersey City. Most of its twenty-eight square miles is tidal marsh covered in dense reeds up to fifteen feet high. In the past there were cedar forests on the high ground, and abundant clay deposits made brick making a successful industry. Unregulated development, landfills, and wholesale dumping went on in the meadows for almost a hundred years. By 1969, 118 municipalities were officially depositing their garbage in the wetlands. That same year, the Hackensack Meadowlands Reclamation and Development Act was passed and a commission was created to preserve the meadows and acquire permanent open space.

The Belleville Turnpike is a two-lane cement-slab road across the meadows, dating from colonial days. Passing through the fens and viewing the stretches of open water bisected by railroad trestles, viaducts, and soaring roadways is a contradictory vision of vast prehistoric marshland and modern times where those intrusions still seem the smaller. The wondrous, monumental Pulaski Skyway, which was constructed in 1932, also crosses the meadowlands. The 3.7-mile-long steel and concrete viaduct, called a "skyroad" or "diagonal highway," is 75 feet high and has two cantilever bridges soaring 145 feet above both the Hackensack and the Passaic Rivers. The iconic skyway, named in honor of Count Casimir Pulaski, a heroic general killed in the Revolutionary War, was the most

Legend has it that Frank Sinatra decided to become a singer after he heard Bing Crosby perform within the gilded walls of Loew's Jersey Theatre (seen on the right) in Jersey City.

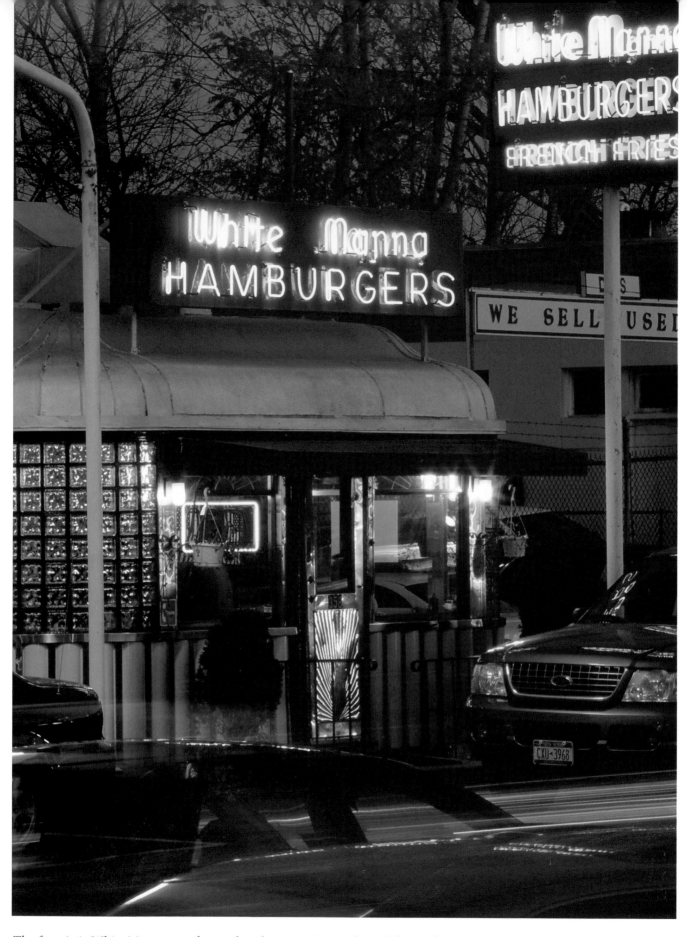

The futuristic White Manna was featured at the 1939 New York World's Fair before being moved to Hackensack.

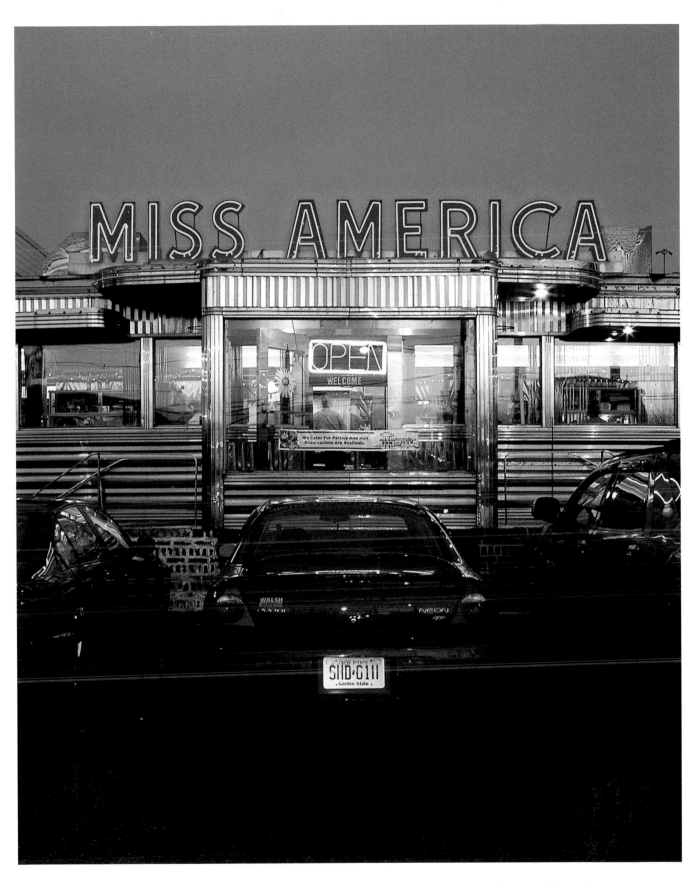

Manufactured in the streamlined style of the 1950s, the Miss America Diner was originally owned by a German immigrant, who named it to honor his adopted home.

expensive and impressive engineering feat of its time. One of Jersey's "seven wonders," its meticulous craftsmanship is marvelous to behold from the roads, trails, and waterways below.

Drive along the ridge that rises along the western border of the meadows through the towns of Arlington and North Arlington to Lyndhurst.

The Colonial Diner, a Lyndhurst 1950s original, is at the top of the hill at the intersection of Orient Way and Rutherford Avenue. The exterior of the Colonial is not colonial in design at all, but instead fits easily into the "diner moderne" style, which includes glass bricks with chrome and enamel on metal paneling. The interior is that of a cozy, railroad dining car with a full counter, original stools, and comfortable sit-in booths. The Hillside Cemetery across from the diner is the final resting place for the poet William Carlos Williams, among many other famous Jerseyans. Regulars arrive in the morning at this spot for eggs, old-fashioned French toast, buttermilk pancakes, or homemade waffles, and then return in the evening hours for full meals like baked meatloaf, roast spring chicken, or broiled seafood platters and spaghetti—all piled high on the plate diner-style. Are you hungry? Then if a walk is in order, try the boardwalk trails over the salt marshes at the Meadowlands Environment Center nearby.

Round out your tour with visits to two more classic diners. The Bendix Diner, wedged in the median of State Highway Route 17 in Hasbrouck Heights, was named after the big Bendix washing machine plant in nearby Teterboro. The Bendix has been seen in countless commercials, and today this unaltered, almost unchanged diner serves delicious diner fare. The only change since the 1950s seems to be in the prices, which are still very reasonable.

The White Manna at 358 River Street in Hackensack is pleasantly situated on a shady lot right on the banks of the Hackensack River. Although the architecture is quite different, the owners of the White Manna, like the owners of the White Mana in Jersey City, also claim that the tiny building was originally on display at the 1939 New York World's Fair. The chromed-metal front, glass bricks, neon signage, and streamlined shape of this tiny, eighteen-seat diner is an excellent representative of the Buck Rogers "World of Tomorrow" theme of that famous World's Fair. Incidentally, the hamburgers, French fries, and milkshakes here are the best.

CITYSCAPE TOUR
NEWARK AND NEIGHBORHOODS

A city's a downtown, and its neighborhoods provide flavor. They change, people move, and suburbs grow. Here, New Jersey has a long history with many flavors. Newark is now on the comeback trail nearly five decades after the 1960s riots, particularly in the downtown area, where the small classic Military Park, with its monuments and wrought iron fence, provides a focus for the surrounding architecture. The historic Hahne's Department Store, on Broad Street, has been made over into luxury condominiums, and the

ROUTE 8

Explore Newark. From Ferry Street, go west on Market Street and turn right on Broad Street. Go north by Military Park, turn left on Orange Street (across from Riverfront Stadium), and go west to a right on Clifton Avenue. Enter Branch Brook Park on the left, follow the park road under the first two bridges, and then keep going left until you can exit north on Bloomfield Avenue (County Route 506 Spur). At Bloomfield center, take a right on Broad Street (County Route 509) to the intersection with Watchung Avenue. Go left, then right on Circuit Drive into Brookdale County Park. At the fork, go right and drive all the way around the park, then retrace your way on County Route 509 to Bloomfield Avenue. Turn left, then take a right on Grove Street (County Route 509), which runs to Irvington. Go right on Chancellor Avenue (County Route 601) and left on Stuyvesant Avenue (County Route 619) to Union.

nearby Robert Treat Hotel—named after Captain Robert Treat, who landed on the shores of the Passaic River at what is now Newark—is a fully functional class-A establishment with facilities for dining, social events, and conventions. Next door at 52 Park Place is the oldest cultural institution in the state: the New Jersey Historical Society headquarters. The society offers exhibitions and programs from illustrated pop-architectural diner tours to examinations of the cultural connections between African art and contemporary African American culture. The Newark Museum, at 49 Washington Street, was reconstructed by Michael Graves, who integrated existing museum buildings into one, great cultural complex. On the museum grounds is the Ballantine House, built in 1885 by John Ballantine, the son of the founder of the renowned Newark brewery. It has been magnificently restored to complete Victorian excess and is a National Historic Landmark.

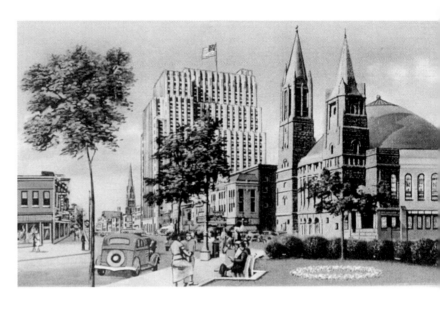

The Art Deco Bell Telephone Building at 540 Broad Street in historic Newark was built between 1927 and 1929.

The Prudential Insurance Company continues to be a mainstay downtown at the crossroads of Broad and Market Streets. Here the Newark Theater marquee from the 1930s has been resurrected as part of Newark's revitalization. A pride of Newark is the restored Pennsylvania Station, constructed in 1933 and designed by Stanford White in the Art Deco style, which features the astrological signs of the zodiac in its interior ceiling fixtures and on its electric-light globes. Throughout the unique station are decorations in the WPA-style of the period featuring railroad, nautical, and Native American motifs. Art Deco enthusiasts come to Newark from all over to see the Bell Telephone Company at 540 Broad Street, an Art Deco skyscraper designed by Voorhees, Gmelin, and Walker, which has relief sculptures on its granite façade depicting telephone workers. The ornate lobby, with its bronze zigzag Art Deco grills and Egyptian lamps, features a two-story terrazzo mural of the god of electricity.

Just behind Penn Station is the Ironbound neighborhood of Newark, which formerly was known as "Down Neck" and is now also called "Little Portugal." Immaculately kept up homes and a fully realized community spirit exist in this fine little neighborhood within a big city. Known for its great Portuguese restaurants—all run by Portuguese-speaking immigrants or second-generation sons and daughters—they offer some of the best cooking in town. With names like Iberia, Fornos of Spain, Tony da Caneca's, or O' Poeta, this concentrated restaurant area is where to go to enjoy a fine meal for those on a shoestring budget.

Drive up Bloomfield Avenue to the North Ward Italian district of Newark, home of the great Cathedral Basilica of the Sacred Heart (located at 89 Ridge Street). This French Gothic cathedral occupies a full block and is the fifth largest Roman Catholic church in the United States.

RIGHT: *The Short Stop Diner in Bloomfield is no longer serving up its famous "eggs in the skillet." It was converted to a Dunkin' Donuts in 2004, but the classic architecture remains.*

FAR RIGHT: *This vintage 1950s sign stands beside U.S. Highway 22 in Union.*

The Cherry Blossom Festival at the Olmsted-designed landscapes of Branch Brook Park draws a diverse throng each spring, but especially young couples and families.

LEFT: *Opening as a vaudeville stage in 1895, the theater was updated as the Art-Deco–style Newark Paramount in the 1930s. It went dark for good in 1985.*

BELOW: *This street lined with storybook homes and blooming magnolia trees is located in a postwar housing development just behind downtown Union.*

With its 9,500-pipe organ, unusual gargoyles, and stained glass windows, it is an architectural monument.

From the cathedral you can drive or walk into Branch Brook Park, one of the famous parks designed by Frederick Law Olmsted, best known for designing Central Park in New York. The landscape is dazzling in April when over 2,500 cherry trees are in bloom along a two-mile stretch known as "Cherry Lane." This spectacular blossom display is larger than the one in Washington, D.C., and is breathtaking in sight and smell to visitors from all over the world.

Newark's North Ward features an amazing array of first-rate, authentic Italian bakeries, pizza joints, and fine, home-style restaurants along the main artery of Bloomfield Avenue, and in the many tree-lined neighborhoods to the right and left. One such restaurant is the Belmont Tavern, known for its "Stretch's Chicken Savoy," cooked in red wine vinegar and olive oil and served with a bowl of spaghetti, ziti, or pasta shells. This is the place where you might find Joe Pesci dining with John Pizzarelli or Frankie Valli—the place where Newark's Italian wise-guys like to eat, drink wine, and hang out. Many scenes in the Emmy-winning TV series *The Sopranos* were shot in the North Ward; there are advertised tours of these locations for fans of the show.

Since the turn of the twentieth century, ice cream parlors have been popular evening, afternoon, and Sunday-after-church family destinations. By the 1920s these sweet shops were in most Jersey towns and were usually owned and operated by German immigrants, who made ice cream, toppings, and chocolate candies on the premises. One of the last remaining old-fashioned ice cream parlors is Holsten's Brookdale Confectionary in Bloomfield. Amazingly, this cool and comfortable corner spot runs just like it did in the 1950s and before. Attractive, young waitresses work the back booths while fresh-faced college and high-school boys man the counter and service the grill. Not to be missed while you are there is the hot-fudge sundae, made with homemade ice cream, fudge sauce, and whipped cream on top, or the thick chocolate or vanilla malteds and hefty ice cream sodas.

Walk off those ice cream calories just across the way from Holsten's in beautiful Brookdale County Park, which features a world-famous rose garden, summer musical concerts, full-scale operas, and spectacular Fourth of July fireworks. There is a drive-through roadway in the twenty-one-acre park; visitors can either tour in their car and enjoy the scenery, or park the vehicle and stroll through the wide-open spaces.

In the 1920s and 1930s New Jersey's suburban areas grew rapidly, and the working-class folk of Union built solid, brick, one-family dwellings. Many of these cozy cottages seen on street after street have peaked roofs made of slate or clay piping, round-topped doors, and windows with wooden shutters on them. During the Depression, building plans for these small "storybook" homes could be purchased out of the Sears catalog and were a direct and welcomed contrast to the great, barn-size, two-family wooden structures that

were built in neighboring, more densely populated towns like Irvington, East Orange, and Newark. Like miniature castles, the little, brick houses of Union were the affordable refuge a typical American worker and his family aspired to in hard times—and they still are.

VALLEY ROAD ROUTE
FROM MONTCLAIR TO PATERSON

In Montclair, Upper Mountain Avenue and Mountain Avenue take you by some of the most magnificent homes in the country, mansions set on the ridge of the Watchung Mountains overlooking the sprawling urban and suburban region below and the Manhattan skyline to the east. Montclair is a shopping, eating, and cultural center. Drive to Church Street, park the car, and stroll around. The town is centered on the elegant, terra-cotta-clad 1928 Hinck Building, which houses shops, coffee bars, and a first-run movie theater. There is an aristocratic feeling about this town in the hills that bespeaks a quieter, slower life for the many residents who commute to jobs in Manhattan.

The Montclair Art Museum is nationally known and just a short block up the hill on South Mountain Avenue at the intersection with Bloomfield Avenue. The Montclair Book Center on nearby Glenridge Avenue offers up the most recently published books, as well as antiquarian books and unusual periodicals, including new and vintage comics. It is a great place to buy and browse to your heart's content. On your way out of town, you will pass by the stately Memorial Park with a lake, spewing fountains, and a spectacular monument designed by Ely Jacques Kahn.

If the town of Montclair is elegant, upscale, and well-kept, Upper Montclair is twice that. Great Tudor- and Georgian-style mansions, a magnificent stone church, and a fine historic firehouse, as well as shops, restaurants, and an old-time movie theater, complete the picture of a self-contained village for the upper-upper-class folk who dwell within the big houses here.

In the nearby city of Clifton, just past Charles Lane and across the road from the Montclair State University's north gate is the John and Anna Vreeland/Hamilton House museum, at 971 Valley Road. Two centuries of American ingenuity are preserved in this early Dutch-style sandstone farmhouse. Built in 1817 the house and the grounds have been restored and refurbished, and are now listed on the State and National Registers of Historic Places. The simple objects farmers utilized in their everyday existence—a spinning wheel, a foot warmer, a crude basin, and an elaborately decorated pitcher—are all on display.

Farther along Valley Road, do the loop on the single-lane road through the Garrett Mountain Reservation. While here, take in the playing fields and the troop transport tank on display, hike up to the old radio tower, or catch an Elvis act in the summertime at Barbour's Pond. Views of the great city of Paterson below are striking. The Passaic County Historical Society runs a museum at Lambert Castle, also known as Belle Vista, a terraced,

ROUTE 9

From Montclair, take Valley Road (County Route 621) north to Paterson. The long driveway to Lambert Castle is at 3 Valley Road. Return south on Valley Road, go right on Mountain Park Road, then right on Weaseldrift Road, and right again on Park Road.

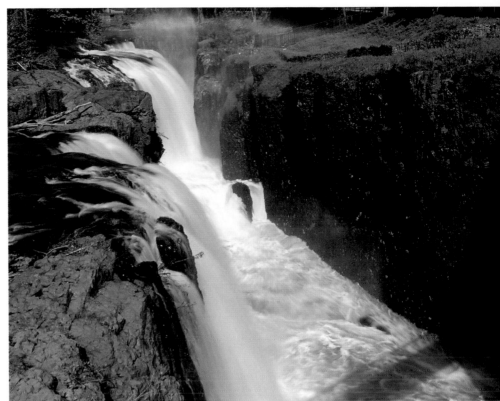

ABOVE: *At the Great Falls, the power of the Passaic River was channeled into canals by the Society for the Establishment of Useful Manufactures to serve the turbines of a planned industrial city.*

LEFT: *This massive Chinese wisteria was planted in 1939 at the Van Vleck House on Upper Mountain Avenue in Montclair.*

turreted, balconied, and towered brick and stone mansion. Built in the early 1890s by Catholina Lambert, a wealthy immigrant silk manufacturer, the rooms in the castle are set in the extravagant 1900–1913, pre–World War I style.

There is much to see and do in historic Paterson, where an encounter between Alexander Hamilton and George Washington proved to become important to the future of American industry. While Washington and Hamilton were having lunch one afternoon in 1778 at the foot of the 78-foot-high, 280-foot-long Great Falls of the Passaic River at Paterson, Hamilton came up with the idea of using the falls' power for manufacturing purposes. In 1791 the Society for the Establishment of Useful Manufactures (S.U.M.) was established by Hamilton and the first factory opened in 1794. Cotton duck cloth for sails was produced at the Paterson mills; in the 1880s, when the cotton industry moved to New England, the mills converted to silk, and Paterson became known as "Silk City."

The planned industrial city of Paterson also manufactured most of America's locomotives. The Paterson Museum is housed in the Thomas Rogers Building, at 2 Market Street, which was the locomotive erecting shop. Paterson was the first in submarines, which were invented, manufactured, and launched on the Passaic River by John Holland. The "Guns that Won the West" were manufactured by the Colt Gun factory, and in the twentieth century airplane engines, including the engine for Charles Lindbergh's *Spirit of St. Louis*, were built at the Wright Aeronautical Engine Division. Due to the prevalence of industry in Paterson, the city endured massive labor struggles and violent strikes. The history of the labor movement in America can be viewed at the Botto House, a national landmark in nearby Haledon.

The Great Falls of the Passaic/S.U.M. Historic District was designated a National Historic Landmark in 1976. Many of the workers' houses have been restored, and a number of the nineteenth- and twentieth-century brick mills have been converted to apartments or studios for artists. A noted Paterson sculptor, Gaetano Federici, sculpted a statue of Paterson native comic Lou Costello adorning Federici Park on Van Houten Street.

Haines Overlook Park is the place to view the falls and the hydroelectric station built in 1922, which is on the park grounds. The visitors' center on McBride Street is in a converted 1930s gas station, and right across the street is a restored Lenni Lenape foot-trail along the ridge of the Great Falls, the second-largest waterfall in the eastern United States.

THOMAS EDISON COUNTRY
ALONG THE WATCHUNG RIDGE

The Edison National Historic Site, on Main Street and Lakeside Avenue in West Orange, showcases the life and inventions of Thomas Alva Edison. Edison put New Jersey on the industrial map, releasing the first practical telephone in 1886. His West Orange research laboratory was built in the summer of 1887, the year he turned forty. The inventor was already famous for his work at the Menlo Park lab, where he had invented the first incandescent

ROUTE 10

Explore the sites of West Orange. Drive south on Main Street, turn right on Northfield Avenue (County Route 508), and then take a left on Walker Road to the Turtle Back Rock picnic area on the right. Return to Northfield Avenue, turn right on Pleasant Valley Way (County Route 636), go under Interstate 280, and take a right turn at Eagle Rock Avenue (County Route 611). Go through the intersection at Prospect Avenue and turn left on Crest Drive into the Eagle Rock Reservation. Take Eagle Rock Avenue back to Pleasant Valley Way, which will become Lakeside Avenue, and continue north. Turn right on Bloomfield Avenue and take another right into Verona Park.

lamp with an electrical distribution system, as well as the first phonograph. During the Industrial Revolution, Edison opened a light-bulb factory in Harrison, which produced 135,000 light bulbs in its first year, and he helped develop a radio system. By 1929, the year of the stock market crash, twelve million Americans listened to the radio in their living rooms, tuning in to newscasts, dramas, and music.

To listen to early Edison recordings of Jerseyites and New Yorkers, tune in to *Thomas Edison's Attic,* a radio show. The host, Jerry Fabris, spins the old cylinders and 78 rpm Edison lateral records each Tuesday evening from seven to eight o'clock on WFMU 9.11 FM, which broadcasts out of Jersey City and East Orange.

In 1891 Edison patented the motion picture camera. Movies had their origin in West Orange in a revolving, square movie studio called the "Black Maria" where the likes of Buffalo Bill and Annie Oakley, who lived in nearby Nutley, were filmed. The first full-story epic movie *The Great Train Robbery* was shot in the Jersey countryside in 1903, and many other early silent films followed. Jersey City became a film center, Fort Lee was a prominent film location in the days of the early silents, and many movies featured the awesome and perilous cliffs of the Palisades.

Edison lived with his wife, Mina, and his daughter in Llewellyn Park on Main Street at Park Avenue. This was, and still is, a gated, private, suburban enclave featuring countless mansions—many of which were constructed in the nineteenth century—set back in the hilly and wooded terrain, surrounded by lush grounds and gardens. Thomas and Mina's red brick and wood mansion, named Glenmont, on Glen Avenue and Honeysuckle Road was originally built by a New York executive who furnished it in an opulent Victorian style using funds embezzled from his firm. The expansive lawns, with a greenhouse, barn, and stables, are where Edison, who died in 1931, rests in a simple gravesite plot. Visits to the Glenmont estate can be arranged through the visitors' center.

Shortly after the crest of the first ridge of the Watchung Mountain range, a left brings you to a rustic woodland picnic ground. Or instead, drive farther north on the high ridge of the Watchungs in West Orange to Pal's Cabin, one of the best restaurants in New Jersey. Opening in 1932 as just a hamburger and hot dog stand, pals Martin L. Horn and Bion LeRoy Sale decided in 1936 to offer a charbroiled steak for fifty cents, at the stand where dogs and burgers sold for ten cents. This spot became so popular that the partners built a full-size restaurant offering up steaks, broiled chicken, lobsters, and their special chef's salad to hungry middle-class folk who, in the middle of the Great Depression, needed a night out at a place they could afford. Pal's once hired an out-of-work pianist named Liberace to tickle the ivories in their cocktail lounge. The piano that he played is still on the premises for viewing. Today, Pal's is run by two of the Horn family sons, Marty Jr. and Don, and their children help out with the business. Pal's Cabin, once a favorite of Babe Ruth and Jackie Gleason, continues to be a must for the best charbroiled steaks and hamburgers in the state.

The Edison National Historic Site in West Orange celebrates the life and times of visionary Thomas Alva Edison, pictured here in his laboratory in 1911. He was first made famous by the phonograph, which he invented in 1877. Photograph courtesy of the Library of Congress, LC-USZ62-106338

On September 11, 2001, a crowd gathered at the overlook in Eagle Rock Reservation to watch in horror as the World Trade Center collapsed. Today, a bronze eagle soars over Essex County's memorial to all those who died that day. The overlook offers a spectacular view of the Manhattan skyline.

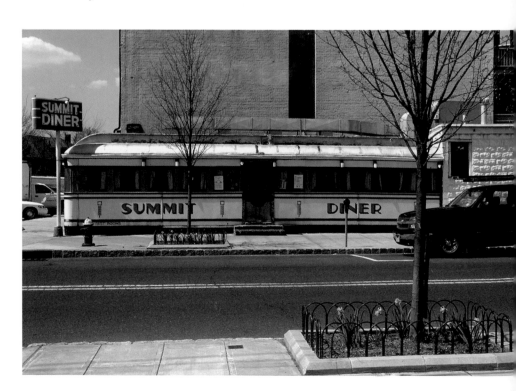

With its barrel-vault roof and moderne enamel exterior, the Summit Diner is a classic of the Depression era.

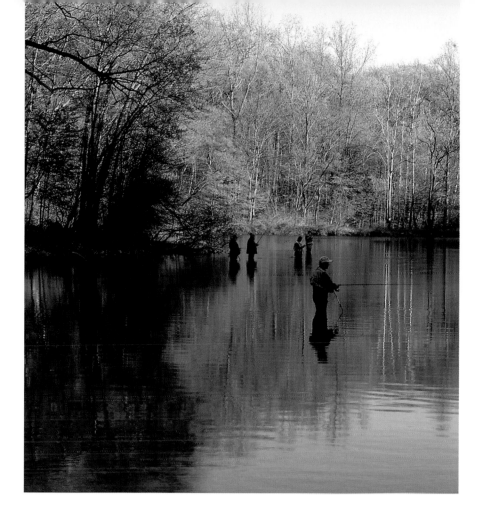

LEFT: *A bucolic scene of flyfishers wading in the South Mountain Reservation's Diamond Mill Pond.*

BELOW: *In the early spring of 1780, the lofty ridge of First Watchung Mountain provided General George Washington's lookouts with a clear view of the deforested valley below, where they could track the advance of British and Hessian troops toward their encampment in Morristown.*

First unveiled as a hot-dog stand, Pal's Cabin in West Orange has been serving its customers well since 1932. Its staff is proud to follow the famed restaurant's "heritage of hospitality," established by the Horn family, who has operated the business since its opening.

ROUTE 11

From Summit, take Glenside Avenue (County Route 527) south to Skytop Drive (County Route 642). Turn left and drive through Watchung Reservation to the Trailside Nature and Science Center. Go back a bit and follow New Providence Road east, passing over U.S. Highway 22. Turn left on Mountain Avenue then right on Park Drive. Go through Lenape Park and turn left on Springfield Avenue (County Route 577) which becomes Meisel Avenue. Cross over State Highway Route 82 to Springfield Avenue (State Highway Route 124), then take Valley Street (County Route 638) to a left on Baker Street. Go through Maplewood Memorial Park and Maplewood center, cross Maplewood Avenue and Ridgewood Road to Ridgewood Terrace, then take a left on Wyoming Avenue. Follow County Route 577 to a right turn onto Millburn Avenue into Millburn center. Take Main Street (County Route 527) north to Brookside Drive and Paper Mill Way, the entrance of South Mountain Reservation.

Leaving the bustle of the busy intersection at Pal's behind, continue up to Eagle Rock Reservation on the crest of First Watchung Mountain. With the advent of the streetcar, this became a mecca for the Sunday idyll, the promenade with a splendid view of Manhattan. At the lookout area, there is a wonderful memorial to those who died in the World Trade Center towers on September 11, 2001. The names of those who were lost that day are inscribed in a polished granite wall below a soaring bronze eagle.

Straddling both sides of the north branch of the Rahway River and nestled between the First and Second Watchung Mountains is verdant Verona Park, created in the late nineteenth century as a picnic and pleasure grounds by the owner of the lakeside property, Captain Hiram Cook. He called it "Eden Wild." In 1900 he sold the property, which included a boathouse, bathhouse, and small pavilion, to the Verona Lake Conservancy. In the 1920s the Olmsted brothers were hired to design the park. Walking across the old stone bridge will transport you to the Verona of William Shakespeare's *Romeo and Juliet*.

PARKS AND NATURE PRESERVES
THE WATCHUNG AND
SOUTH MOUNTAIN RESERVATIONS

This tour begins in downtown Summit, where you can take time to enjoy a classic diner before embarking on your journey. The historic Summit Diner, at 1 Union Place across from the railroad station, is one of New Jersey's oldest, dating from 1938. With its baked-enamel-on-metal, wood, and stained-glass exterior and wooden interior, a visit here is truly like stepping into an old railroad car. The Depression-era style meals include meatloaf, gravy, mashed potatoes, and canned peas just as mother served it way back then. The steaming hot coffee can't be beat and the bacon is piled

high on its classic BLT, which is claimed to have been a favorite of Ernest Hemingway when he stopped by. There is no stinginess at the Summit Diner.

After refueling at the Summit Diner, begin your trip at the Trailside Nature and Science Center. The center is in two-thousand-acre Watchung Reservation and features New Jersey's first natural history museum, which opened in 1941. There are thirteen miles of marked hiking trails, including the ten-mile Sierra Loop in this mountainous nature preserve. Drive up around the circle in the center of the reservation, check out the sky tower off Tracy Drive, and return to New Providence Road.

Echo Lake Park is contiguous with pond-filled Lenape Park, which is contiguous with Black Brook Park. The natural area created by these connecting parks attracts numbers of waterfowl and migratory birds, and the trails offer excellent opportunities for rare sightings. Take Valley Street to the last of our little parks, Maplewood Memorial Park. Walk through the park and under the train trestle to the old-fashioned and upscale town of Maplewood.

Continuing your drive to Millburn, at the town's center is Millburn Park, located at Main and Town Hall Avenue. The park has an attractive landscape, designed by Frederick Law Olmsted, and is bisected by a swift-moving stream—actually the west branch of the Rahway River. Millburn, founded in 1857, is famous for the Papermill Playhouse, which is housed in an old paper mill that operated from 1795 to 1926. In 1934 the mill was turned into a theater. Rudolph Friml operettas, which attracted German immigrants who had settled into the nearby towns of Irvington and Union, were big box-office draws in the early days, as were the musicals of Jerome Kern. Out of town Broadway tryouts later filled the bill here and brought luminaries such as Geraldine Page, Sandy Dennis, Tallulah Bankhead, Ethel Barrymore, and Uta Hagen to the stage.

Bordering on the towns of Millburn, South Orange, and Maplewood is a 2,048-acre forest preserve called the South Mountain Reservation. With tall stands of trees jutting up the hills on either side of the river in a north-south valley stretching for miles, this woodlands retreat is only a half-hour drive from the crowded city of New York. The reservation's splendid landscape was also designed by Frederick Law Olmsted and is set on three high Watchung Mountain ridges with picnic areas, a deer paddock, and a rock waterfall region. Hikers on the Oakdale, Cascade, and Lenape trails can walk in the footsteps of the Lenape tribes before them. When you drive into the reservation, take a right at the first intersection, South Orange Avenue, and follow the road down the hill and back up again. Take a right turn onto Crest Drive to the gate, and it's a short walk to continue to Overlook Rock. The ridge-top rock has a strategic valley view that is clear to Perth Amboy and Raritan Bay. It was used by the Lenape—and later by George Washington—as a lookout point.

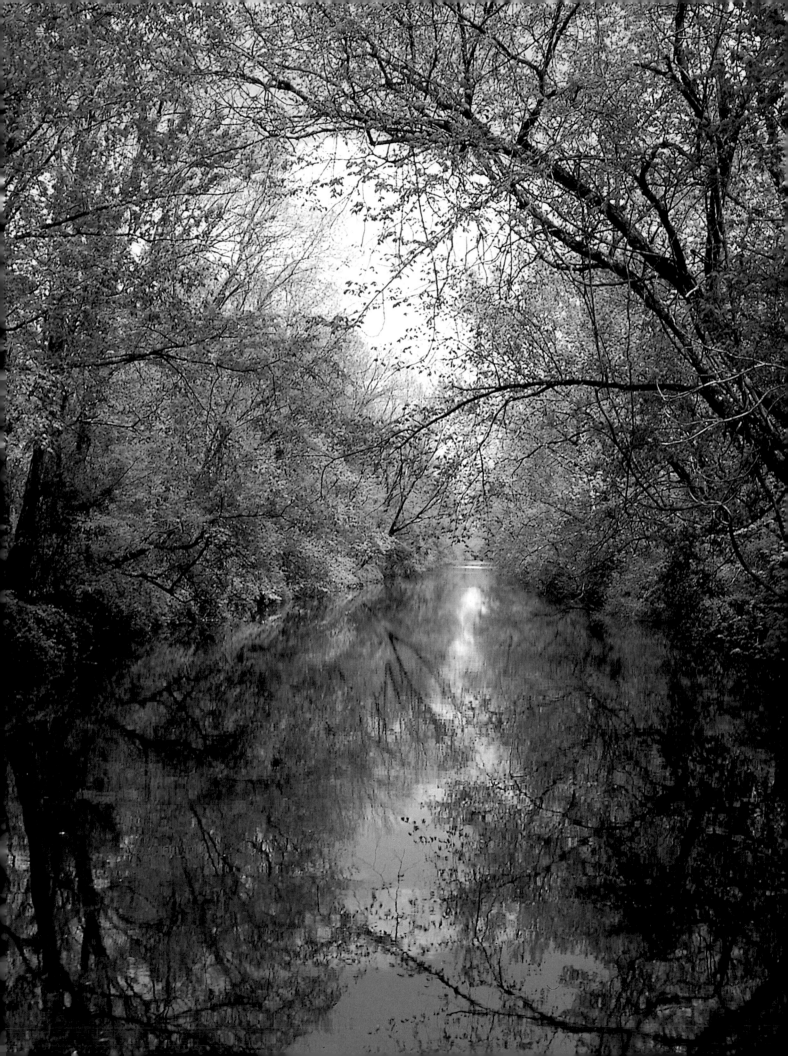

THE CENTRAL BELT
CROSSROADS

ABOVE:

The Perth Amboy City Hall is the oldest in continuous use in the country. Renovated in 1826 and 1872, some of the 1767 structure still remains.

FACING PAGE:

Opened in 1834, the Delaware and Raritan Canal primarily carried anthracite coal from Pennsylvania.

The state of New Jersey has a tight waist. A corridor along the inner coastal plain crosses the state, with the rolling hills of the Appalachian Piedmont on the north, and a string of glacial ridges, or cuestas, on the south to separate it from the outer coastal plain. At the time of coach and ferry, the King's Highway provided a vital link between northern and southern colonies. With the British on York's Island (Manhattan) and the Continental Congress meeting in Philadelphia, troops marched in formation back and forth for battles of critical importance. The economic impact of a canal from the navigable waters of the Raritan River to those of the Delaware at Bordentown spurred the industrial growth of a still young republic. Rail lines soon followed. The age of the automobile is heralded by the presence of U.S. Highway 1. Of course, the New Jersey Turnpike follows. Today, in a single linear park, you can walk, peddle, or paddle your way nearly across the state.

RARITAN ROADS
FROM RARITAN BAY TO THE DELAWARE AND RARITAN CANAL

The land the Lenape called *Ompoge* became Emboyle, then Amboyle, and finally Amboy Point, or Amboy, when the city incorporated; Perth was added when it became the capital of East Jersey to honor one of the Proprietors, the Earl of Perth. (East and West Jersey became New Jersey in 1702.) During the American Revolution this strategic city, located at the mouth of the Raritan River, was occupied by both armies. Perth Amboy was the first major industrialized city in the region, ablaze with smelting and copper refineries, and local clay deposits created a major brick, ceramic, and terra-cotta tile and pipe industry. The central City Hall Park, on the site of the original marketplace at Market and High Streets, is graced with a fine statue of George Washington. The town boasts a grand collection of eighteenth- and nineteenth-century houses and commercial buildings from the 1910s and 1920s. Take a keen look at the rare and unusual historical memorabilia on display at the Proprietary House, the only official Royal Governor's Palace still intact from colonial days.

From Perth Amboy, you will drive into Thomas Edison territory. Edison Memorial Tower and Museum is a small state park on Christie Street, just off the Lincoln Highway in Menlo Park. Edison, the "Wizard of Menlo Park," lived here, and this is where he established his first lab, which was in operation from 1876 to 1886. Today the 131-foot Thomas A. Edison Memorial Tower, constructed in 1937, rises from the center of a field in a working-class neighborhood on the site of Edison's original wooden tower, which featured a single, extra-large light bulb. The current concrete and marble Art Deco tower, added to the National Register of Historic Places in 1979, is topped by a replica of an incandescent light bulb, fourteen feet high and nine feet in diameter. This gigantic light bulb is an outstanding sight atop the tower, and from its high point at the top of the hill, the pop-

ROUTE 12

From Perth Amboy, take New Brunswick Avenue west (County Route 616, becomes 501). Turn right on Woodbridge Avenue (County Route 514) and left on Grand View Avenue. Make a right turn on Lafayette Avenue and a left on Roosevelt Drive. Take Oakwood Avenue north out of Roosevelt County Park. Make a left turn on North Evergreen Road to Lincoln Highway (State Highway Route 27), then head south through Menlo Park and Highland Park to New Brunswick. Turn right off Lincoln Highway onto George Street (County Route 672) and left on Hamilton Street (County Route 514), which becomes Amwell Road on its way west to Millstone. Take a left on Main Street then follow Millstone River Road (County Route 533) south and cross the river on the Griggstown Causeway. To reach the Rockingham historic site, go south on Canal Road then continue on Kingston-Rocky Hill Road (County Route 603).

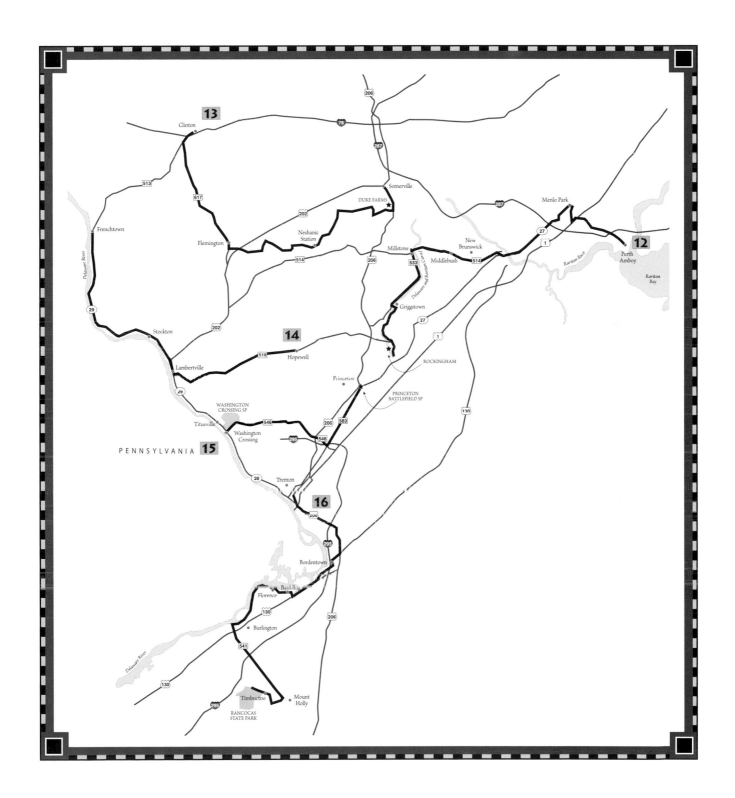

ABOVE: *The bridge tender at Blackwells Mills had the job of opening the swing bridge for barge traffic on the Delaware and Raritan Canal. Generations of bridge tenders lived in the canal house, which was built in the 1830s.*

RIGHT: *A bronze relief of Thomas Alva Edison is on display in Menlo Park. At the site of the world's first research and development laboratory, you can take the path to the fishing pond where Edison walked "to think."*

ABOVE: *The towpath in Delaware and Raritan Canal State Park provides a continuous thirty-four mile trail to hike or bike through woods along the floodplain of the Millstone River and by locks and other historic structures.*

LEFT: *Spring is in full bloom at the Griggstown causeway. A busy road today for commuters, the Continental Army passed here on the way to winter encampment in Morristown after the victory at Princeton.*

The Thomas A. Edison Memorial Tower, built in 1937, is a tribute to Edison's invention of the incandescent light bulb.

culture icon can be seen for miles around. Next door to the tower is the Menlo Park Museum, a small, cozy, house-like structure modeled after Edison's original laboratory. Here, visitors can view some of Edison's tools and early inventions, a selection of the first light bulbs, and Edison Company toasters, gramophones, cylinders, seventy-eight rpm lateral records, and more.

Near the shallows where Lenape trails to the seashore forded the Raritan River, John Inian established a ferry crossing in 1681. A later bridge was destroyed by George Washington to slow the British as he retreated west. New Brunswick was chartered by King George II in 1730, but it wasn't until 1929 when the 110 square miles of its present town boundaries were set. Queens College was founded in 1766 and, today, is divided into the New Brunswick Theological Seminary and Rutgers, the State University.

In Middlebush just off Amwell Road on County Route 615 at Bennett's Lane is the largest cow east of the Mississippi, a Holstein fixture at the Middlebush Farm. Farther west is Colonial Park, a 568-acre natural area on Mettler's Road off Amwell Road. The wooded park is bisected by Spooky Brook and there are two fishing and swimming ponds. The Rudolf W. van der Groot Rose Garden is located in the park and is world renowned for its varieties of roses. There is also a five-and-a-half-acre arboretum, filled with horticultural wonders.

On your left, just before you get to Millstone, is the 206-acre William Hutcheson Memorial Forest maintained by Rutgers University Department of Biological Sciences. This is one of the last uncut oak-hickory forests in the Mid-Atlantic states—the average white oak is more than two hundred years old—and is a living laboratory. Tours are given on Sundays. The East Millstone Historic District has a wonderful collection of old houses built of wood and covered in stucco. The roads south, on both sides of the river, provide glimpses of farmhouses dating back to the early nineteenth century.

Used primarily for the transportation of coal from 1834 until 1932, the part of the Delaware and Raritan Canal on your route once stretched unbroken from the Delaware River to the Raritan River at New Brunswick. Thirty-six miles of the main canal, and twenty-two miles of the feeder canal along the Delaware River, are preserved in the Delaware and Raritan Canal State Park. They are ideal for hiking, jogging, fishing, canoeing, and bicycling.

Griggstown is the place to experience firsthand an early American canal village. There is a quaint, small bridge over the canal, the bridge tender's house and station, and the site of a nineteenth-century mill. The mule tenders' barracks was once home to a beloved museum, which suffered severe flooding but was restored in 2007.

Winding through wooded roads, make your way to Rockingham, the oldest house in the Millstone River Valley, its earliest section constructed in 1710. George and Martha Washington both stayed in Rockingham for a few months in 1783 when the newly elected president gave his farewell address, "Farewell Orders to the Armies of the United States."

FARMLANDS AND ESTATES
OF CENTRAL JERSEY
CLINTON, FLEMINGTON, AND SOMERVILLE

The Red Mill Museum Village in Clinton, on a ten-acre site along the banks of the South Branch of the Raritan River, brings to vivid life the history of the thriving quarry and mill days of long ago. The 1810 Red Mill is known as a symbol of early America's rural industry. Investigate the Bunker Hill schoolhouse; the Mulligan quarry tenant house, general store, wagon sheds, and corncribs; and a replica of a 1730s log cabin. Pause to enjoy the rolling lawn, herb garden, and towering stone cliffs.

Cross the circa 1870 truss bridge along a two-hundred-foot-wide waterfall to the other side of the river. These historic bridges stand as a reminder of the area's industrial heritage and importance as a transportation link between urban centers. Their roll as a precursor to iron and steel frame bridges has also merited developing preservation plans. View contemporary art in the Hunterdon Museum of Art's 1836 stone gristmill, then shop in Clinton's downtown district or take a seat in a riverside cafe.

Flemington had the first egg and livestock auction market in the state and once was the site of the annual agricultural fair, where the bounty grown on local Jersey farms was the main focus. The town center is a historic district, and 65 percent of the buildings are listed in State or National Registers of Historic Places. The feeling you get while walking the charming streets surrounding the town center is much like what it must have been when the town was a bustling center of agriculture for the vast farming region. On the main and side streets are antiques shops and some very fine restaurants. Fuel up on the great Sicilian pizza that locals call the best in Jersey at Jack's Pizzeria, a mainstay at 55 Main Street.

The old County Courthouse, an 1820s Greek Revival building at Main and Court Streets, is the place where Bruno Hauptmann was tried for the kidnapping and murder of Charles Lindbergh's twenty-month-old son, Charles Augustus Lindbergh Jr. The sensational trial was a major media focus that went on for months, but eventually Hauptmann, who hid the $13,500 in ransom money at his Bronx home, was found guilty and executed for his crime. During the trial, the press retreated to the Union Hotel, across the street at 76 Main Street, which had a good restaurant and bar and where they could use telephones to call in their daily reports of the trial. This grand hotel was rebuilt after a fire in 1826, and it was rebuilt again in 1877–1878.

It is wonderful to see the convergence of the Neshanic and Raritan Rivers at the country crossroads, which on weekends is the site of a farmers' and antiques market. On hot summer days, happy visitors sometimes like to take a dip in the river, just as they did in the old days. The village of Neshanic Station has some extraordinary Victorian structures, survivors from the days of wealthy mill owners.

ROUTE 13

From Clinton, take West Main Street (County Route 513) under Interstate 78 to Sidney Road and follow County Route 617 onto North Main Street and into Flemington. From Main Street, go left on Church Street; County Route 650 becomes Voorhees Corner Road, and take Old York Road north (County Route 613). Just before the South Branch of the Raritan River, go right on Hillsborough Road, then Three Bridges Road, and left on Woodfern Road, which eventually turns onto Main Street in Neshanic Station. Take the right on Elm Street and cross the river to County Route 567. Stay on River Road where County Route 567 splits off, continue through South Branch (now County Route 625) and make an extreme right onto Roycefield Road, then a left onto Dukes Parkway West. At U.S. Highway 206, make a left turn on Dukes Parkway East to the Duke Gardens. Continue north on U.S. 206 to reach Somerville.

RIGHT: *The upland Black River is a tributary of the North Branch Raritan River. Along it you can walk by a restored mill, visit a garden, or drive through a deep ravine.*

BELOW: *The hamlet of Locktown got its name from an 1839 dispute when one faction of the Stone Church's congregation tried to lock out the other.*

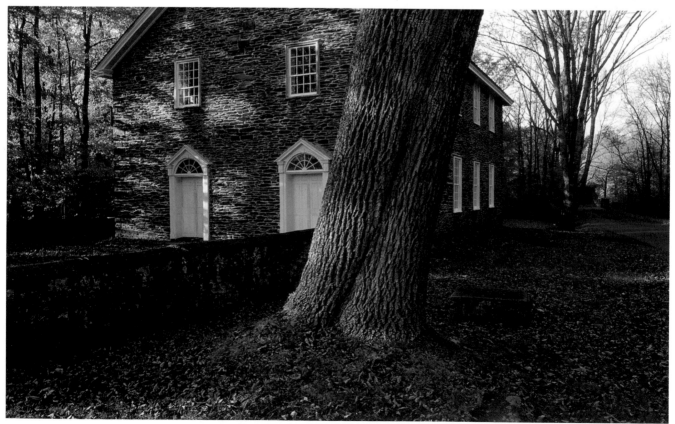

The towns of Mount Holly, Hopewell, Lambertville, Frenchtown, Chester, and Lafayette in old West Jersey are all known for their antiques shops.

Historic structures connect the towns of Hunterdon County. This one, built in 1902 on Three Bridges Road in Three Bridges, spans the winding South Branch Raritan River.

Inherited by heiress Doris Duke in 1925, the lush Duke estate was first developed as early as 1893. Today, visitors can tour the magnificent gardens, which are owned and operated by the Duke Farms Foundation.

The Raritan, New Jersey's most impressive river, was called by the Nariticong Indians of the Raritan tribal nation the *Laletan*, which means "forked river." The tribe grew maize, beans, pumpkins, and fruit in the fertile Raritan Valley, and it was here the first Dutch settlers found them living productively and peacefully on the land. The confluence of the north and south branches of the Raritan River occurs at South Branch, along the Delaware and Raritan feeder canal. You can take a footpath loop from the visitors' center at Duke Island Park to the head gates dam of the Raritan through woods and meadows, and there is a large picnic pavilion to take shelter in case of sudden showers.

The Duke mansion and estate, south of Somerville, is set on two thousand acres of private grounds, adjoining to the south with four thousand acres of farmland. Known as Duke Farms, the largest private estate on the East Coast was considered by the glamorous heiress Doris Duke to be her primary base and true home. The great house and landscape, originally developed by her father, tobacco and power magnate James Buchanan Duke, was maintained by Doris from 1925 on when "Dee Dee," as she was called, inherited it at the age of twelve. Twice divorced, Doris Duke—who was tagged the "richest girl in the world"—lived out a lavish but lonely life. Among her closest friends who often stayed with her in her fabulous New Jersey digs were Imelda Marcos, Gloria Swanson, Betty Hutton, Peggy Lee, and Paul "Pee-Wee Herman" Reubens.

The meticulously maintained estate has over eighteen miles of road, two million trees, ten waterfalls, thirty-five fountains, and nine lakes. The famous Duke Gardens, set back in the grounds of the Duke Estate, consist of eleven connected high-vaulted Victorian glass hothouses, each one featuring a different garden theme. Doris Duke opened the gardens to the public in 1964, by appointment. The first garden you enter is the American Colonial, which features clipped hedges, camellia bushes, and magnolias. Next, you enter the British Colonial Edwardian garden with its palm trees and rubber plants. The formal French and English gardens lie beyond. A southwest desert garden is next; then a Chinese garden complete with mysterious stone grotto; landscaped Japanese gardens; an Indo-Persian garden replicating the gardens of the Taj Mahal; a miniature African rainforest; an Amazon garden; and a semitropical Mediterranean garden. After Doris Duke's mysterious death in 1993 the Duke Foundation opened up the sprawling fifty-five-room mansion for select tours by advance reservation.

Somerville is the county seat of Somerset and a busy antiques center of note today. The Antiques Emporium at 29 Division Street is a good place to start an antiques hunt. This is an architecturally prominent country town with impressive nineteenth-century homes and some pre–Revolutionary War buildings. The Wallace House on Washington Street, built in 1775, is a restored colonial home which served as General Washington's headquarters

during the winter of 1778–1779. Next door is the Old Dutch Parsonage, a Dutch Colonial building from 1751.

One of Doris Duke's hobbies was to restore colonial houses in Somerville and in the Raritan area. These were furnished and decorated with both exquisite taste and great simplicity by the heiress herself. She preferred to rent these restored and refurbished homes to gentlemen professionals. One, William Singer, a noted New Jersey lawyer, took these authors on a private tour of the Duke house he lived in. Although he made out his rent check each month to "Doris Duke," he, unfortunately, never got to meet the mysterious lady who was sometimes referred to as "the elusive butterfly."

ANTIQUES AND RIVERTOWNS
HOPEWELL TO FRENCHTOWN

The Delaware River was called the *Zuydt*, or "south river," by Dutch explorers in 1623 to distinguish it from the North River, which the English would rename the Hudson when they took control in 1673. The *Zuydt* was renamed to honor Lord de la Warr. And so New Jersey came to be settled from both the west and the east. The first farm in Hopewell was established in 1690, and the town was incorporated by royal charter in 1755. Following the English settlers came Dutch, Huguenot, Scottish, and Irish immigrants to partake of the rich soil. Today the area is rural countryside interspersed with farms, and the town of Hopewell itself contains a collection of fine nineteenth- and early-twentieth-century buildings.

Charles Lindbergh and his wife and child lived on a four-hundred-acre estate near Hopewell, in the Sourland Hills. Since Lindbergh's audacious first solo flight across the Atlantic to France in 1927, he was regarded as one of America's greatest heroes and icons, with all the world cheering his achievement and singing the popular song of the day, "Lucky Lindy." Nevertheless, a dark event occurred that would haunt Colonel Lindbergh and his wife, Anne Morrow, for the rest of their lives. On March 1, 1932, their son, Charles Lindbergh Jr., was kidnapped. Over two months after the kidnapping, beside a lonely backroad not far from the estate, the baby's remains were found. A two-year manhunt ended with the incarceration of an unemployed carpenter named Bruno Hauptmann. The sensational trial, held in the town of Flemington, lasted six weeks and attracted worldwide headlines, being called the "Crime of the Century."

The feeder canal section of Delaware and Raritan Canal State Park runs north and south along the Delaware River from Lambertville. It was built to supply water to the main canal, but was also used by cargo vessels. For fishermen, the river and canal yield up perch, pickerel, bass, and sunfish, and the waters are annually stocked with trout. There are boat launch sites at several points along the way and a multi-use trail, which stretches from Trenton to Frenchtown.

ROUTE 14

From Hopewell, take the Lambertville-Hopewell Turnpike (County Route 518) west. Drive north on State Highway Route 29 along the Delaware River from Lambertville to Frenchtown.

Early Dutch, Swedish, and English explorers and settlers traveled up the Delaware River to the interior wilds of New Jersey. Seen here at Bull's Island, the Delaware may be considered the front door to the state.

This classic, old-style gas station is found on a backroad near Lambertville.

John Hart, a signer of the
Declaration of Independence,
donated a parcel of his front meadow
to the Baptists to build
a church. A Presbyterian, he was
later re-interred here for a memorial
in Hopewell.

This early gristmill, located in the
Prallsville Mills Historic District, sits
above a feeder canal for the Delaware
and Raritan Canal at Wickecheoke
Creek. The railbed for the Belvidere &
Delaware Railroad also passes by this
1877 stone structure.

Charles Lindbergh, the first person to fly solo across the Atlantic Ocean, shared a house with his wife and son near Hopewell, New Jersey. After his son was tragically kidnapped and murdered in 1932, the ensuing trial was held at the courthouse in nearby Flemington. Photograph courtesy of the Library of Congress, LC-DIG-ggbain-35317

The river crossing at Lambertville was originally used by Native American tribes. In the early 1700s the town was settled by Europeans, and in the nineteenth century it prospered with a variety of industries, including lumbering, sawmills, gristmills, and iron and rubber manufacturing. Goods were transported to market on the Delaware and Raritan Canal and on the Belvedere & Delaware Railroad. Today the Lambertville Station is where you can board a steam-driven locomotive for the Black River & Western Railroad's forty-five-minute farm-country train excursion with stops at Flemington and Ringoes.

The town of Lambertville is filled with historic buildings, intimate restaurants, and quaint antiques emporiums, such as the People's Store at 29 North Union Street (at Church Street), a forty-shop cooperative antiques center built in 1854. For floor-to-ceiling new, used, rare, and antiquarian books, stop at Phoenix Books at 49 North Union Street. Built in 1812, the Lambertville House Historic Inn was once a stagecoach rest stop and tavern serving those traveling between Philadelphia and New York, including business leaders, dignitaries, and even President Ulysses S. Grant. The inn, which has an imposing façade of quarried stone etched with wrought-iron balustrades, has been in continual operation for almost two hundred years. In addition to this impressive piece of architecture, many of the town's great houses, in the Gothic, Victorian, Greek Revival, Italianate, Queen Anne, and Southern ornate styles, have been recently restored to their former glory.

The steel bridge crossing the Delaware River from Lambertville to New Hope offers wonderful views of the river. If you have time to explore another idyllic village, park the car and walk across the bridge (and across the state border) to Pennsylvania's famous Bucks County and the historic canal town of New Hope.

For another detour, drive about three miles south of Lambertville on scenic State Highway Route 29 to one of the state's major antiques venues, the Golden Nugget Antique Market, open every Wednesday, Saturday, and Sunday all year round. This is a famous market—one of those places where you can find the proverbial "antiques road show" attic treasures. There are permanent inside dealers and, in good weather, hundreds of outdoor vendors selling, bartering, and bargaining from dawn 'til dusk. For those in search of bric-a-brac, antique picture frames, quilts, World War II military souvenirs, furniture, baby carriages, flags, or Depression glass, the Golden Nugget Antique Market is the ultimate destination.

The first ferry crossing on the Delaware River was inaugurated in Stockton, north of Lambertville, in 1711. The town's Stockton Inn was constructed in 1710 as a residence and expanded in 1832 as a restaurant and hotel, which it has been ever since. The now-famous wishing well on the premises was immortalized in the Rodgers and Hart song "There's a Small Hotel."

Bull's Island is an eighty-acre state recreation area on the Delaware River, about four miles north of Stockton, and is part of the Delaware and Raritan Canal State Park. The Prallsville Mills Historic District is also in the park, bounded by

the Delaware River, Wickecheoke Creek, and State Highway Route 29. It has a charming waterfall and a fine collection of homes and commercial buildings that include a nineteenth-century sawmill, gristmill, and linseed-oil mill.

Originally a ferry crossing, Frenchtown was a farming center, then industrial and mill town that thrived throughout the nineteenth century. The architecture ranges from early American to Victorian ornate, and there are art and antiques galleries, as well as design boutiques, and some very good restaurants here. For fine dining, try the Frenchtown Inn on Bridge Street by the river, or for more casual fare, the Bridge Cafe across the street. A smaller town, and more recently rediscovered, Frenchtown has its own ambience.

REMEMBERING THE REVOLUTION
WASHINGTON CROSSING TO PRINCETON

Following the signing of the Declaration of Independence on July 4, 1776, New Jersey found itself in the middle of the fight for freedom, earning the nickname "Cockpit of the Revolution." General George Washington spent a significant amount of time in New Jersey, but whenever the British redcoats tried to catch up with the cunning leader, he always seemed to disappear. At times he would sleep outdoors under a tree, in a thicket buried under leaves, or in a self-made trench; at other times the general spent the night in the house of a patriot. Even today, colonial inns in the state hang up signs stating the legend, "George Washington Slept Here"—and he probably did!

The town of Titusville is home to Washington Crossing State Park. Its visitors' center and museum opened in commemoration of America's Bicentennial in 1976, and interprets the nation's "Ten Crucial Days"—December 25, 1776, through January 3, 1777—during the Revolutionary War. The events of these ten days included the Continental Army's crossing of the Delaware River and the Battles of Trenton and Princeton, which were the first major victories for Washington's troops against the British forces. Also in the park is the Johnson Ferry House where General Washington and his staff finalized the strategy for the attack on Trenton, eight miles to the south. Troops were formed up on the New Jersey bank of the river and marched off from there for the early morning assault.

In December 1776, Washington's troops were in Pennsylvania, driven there by the British army. Using a network of spies, General Washington learned that British General William Howe had taken his troops to New York for the winter, leaving behind a force of 1,500 unruly Hessians at Trenton. On December 23, General Washington wrote a letter to one of his colonels in which he stated, "Christmas day at night, one hour before day, is the time fixed upon our attempt on Trenton. For Heaven's sake keep this to yourself as the discovery may prove fatal to us." Washington marshaled his 2,400 troops on a bitter cold Christmas evening and in large, flat-bottomed boats they rowed across the icy Delaware River into New Jersey. A northeaster broke, and as they moved stealthily toward Trenton, two men froze to death. But the storm was also their ally, for the Hessians had not posted adequate guard, and when

ROUTE 15

From Washington Crossing, drive east on County Route 546, cross State Highway Route 31, cross U.S. Highway 206, and turn left on Princeton Pike (County Route 583) to the Princeton Battlefield State Park. Continue north on Princeton Pike to explore historic Princeton.

ABOVE: *George Washington passed here in 1777. Today, the Crossroads of the American Revolution National Heritage Area encompasses fourteen counties and several hundred national historic sites in New Jersey.*

RIGHT: *Princeton University's mascot tigers guard the entrance to Nassau Hall, much as sentries may have when it was used to quarter British and then Continental troops during the Revolutionary War. Now housing the university's main administrative offices, "Old Nassau" hosted the Continental Congress in 1783.*

Grovers Mill was the imagined site of a massive attack . . . by Martians, in Orson Welles' 1938 radio broadcast of H. G. Wells' The War of the Worlds.

George Washington and his troops stealthily cross the Delaware River to surprise the Hessian troops at Trenton, as depicted in this print by Currier and Ives.

Washington's forces attacked at one hour after daylight, the enemy was taken completely by surprise. The sleeping Hessians awoke defenseless to the cannon at the head of King and Queen Streets, and rebels with fixed bayonets awaited them in the refuge of the side streets. No Americans were lost in this fierce battle, while twenty-one Hessians were killed, ninety wounded, and approximately nine hundred captured. In forty-five minutes or less, the tide of Washington's long retreat from Fort Lee on the Hudson had been turned. Within days, newspapers were filled with accounts of the victory.

On January 3, 1777, about a week after the victory at Trenton, the Battle of Princeton was forged when a unit of patriots led by General Hugh Mercer joined Washington's troops, driving the British led by General Cornwallis into retreat to New Brunswick. Score another important victory in the Revolution. Adjacent to Princeton Battlefield State Park, the site of the skirmish, is the Charles H. Rogers Wildlife Refuge and Institute Woods, a three-hundred-acre woodland area and a grand place for bird-watching. There is an open observation tower, trails to follow, a marsh, and a wonderful suspension bridge over Stony Brook.

The town of Princeton offers many more historical sites. The mansion at Morven Museum and Gardens was constructed at 55 Stockton Street in 1758 by Richard Stockton III, a signer of the Declaration of Independence, and his wife, Annis Boudinot Stockton, a published poet. Later, it was the home of the founder of Johnson and Johnson, Robert Wood Johnson, and from 1945 to 1981 it was the governor's residence. Drumthwacket, the stately Princeton mansion built in the Greek Revival style in 1835, was made the official residence of New Jersey's governors in 1981.

Bainbridge House, built in 1766 is at 158 Nassau Street and is the headquarters of the Historical Society of Princeton. A collection of over forty thousand manuscripts and artifacts is kept here. In 1783 members of the Continental Congress lived in the building, most of which remains intact.

The Ivy League Princeton University, with its black and orange school colors and striped tiger mascot, has been the study-home of many great thinkers, statesmen, writers, actors, and historians and is considered one of the greatest academic institutions in the world. Among Princeton's former students are such luminaries as Woodrow Wilson, Ralph Nader, James Stewart, Henry Fonda, Brooke Shields, and the famed actor-singer Paul Robeson, a Somerville native, Phi Beta Kappa, and all-American football star. Eugene O'Neill was a part-time student who drank whiskey in his dorm and acted in Triangle Club productions, and F. Scott Fitzgerald spent a total of three years there. The campus is set in the middle of the attractive town of Princeton, with its mix of European, Gothic, Georgian, and twentieth-century buildings, and is an impressive place to stroll through on an autumn or spring day. Historical and modern outdoor sculpture abound on the beautiful landscaped grounds, dotted with works by David Smith, Louise Nevelson, George Segal, and Pablo Picasso.

To see more outdoor artworks, take a side trip to visit twenty-two-acre Grounds for Sculpture at 18 Fairgrounds Road in Hamilton, located two miles east of Trenton. Noted sculptor J. Seward Johnson Jr. founded Grounds for Sculpture, which had its inaugural exhibition in June 1992, on the site of the old New Jersey State Fair. The serene, contoured landscape includes watercourses, reflecting pools, ponds, ecosystems, and woodlands with hundreds of varieties of trees and shrubs. It also features thousands of rosebushes and other flowers, as well as striking sculpture sites and sculpture walls. One sculpture group is a realistic bronze grouping entitled *Depression Breadline*, a tribute to Franklin Delano Roosevelt created by one of the foremost, contemporary figurative sculptors, George Segal, who was a New Jersey resident from the 1950s until his death in 2000. Founder J. Seward Johnson, an heir to the Johnson and Johnson pharmaceutical fortune, has also established a gourmet restaurant set in the lovely gardens called Rat's Restaurant.

THE HISTORIC STATE CAPITAL REGION
TRENTON TO TIMBUCTOO

The unofficial slogan of industrial Trenton, the capital of New Jersey and the Mercer County seat, is "Trenton Makes, the World Takes," which is spelled out in giant, electric letters on a steel sign atop the bridge erected in 1917 over the Delaware River. Trenton was the home of Peter Cooper's Trenton Iron Company, the John A. Roebling's Sons Company, and hundreds of manufacturing companies that made everything from Lenox china to linoleum.

But more than just an industrial city, Trenton is a historic city. Founded in 1679, it saw pivotal battles during the American Revolution and was designated the official state capital in 1790. For a bird's-eye view of the capitol building, battle sites, and surrounding countryside, take the elevator to the top of the 150-foot observatory at Trenton Battle Monument.

In 1885 the gold-domed State House was erected at 125 West State Street. Also on West State Street and in the Capitol Complex is the New Jersey State Museum, which has examples of New Jersey manufacturing such as furniture, china, and pottery. The 1719 William Trent House at 15 Market Street was home to at least three New Jersey governors and is restored with Georgian furnishings. Referred to as a "true gem" of the William and Mary period in America, the house and its beautiful gardens are the centerpiece of this old capital city.

The Old Barracks Museum on Barrack Street, built between 1758 and 1760, was being used by Hessians, loyalist refugees, and sundry camp followers and dependents when General Washington's troops surprised them in an attack that turned the tide of the American Revolution. Rich in history, the Old Barracks is also considered a fine example of colonial architecture.

South of Trenton at the confluence of Crosswicks Creek and the Delaware River is Bordentown, a former industrial town established in 1682. On a bluff overlooking the creek, Hilltop Park at the end of Farnsworth Avenue is an

ROUTE 16

Explore historic Trenton. From Trenton, take South Broad Street (U.S. Highway 206), which becomes Bordentown Road, to a right on Park Street (County Route 662). Take a left on Farnsworth Avenue (County Route 545)—the main street in Bordentown—and a right on West Burlington Street. Drive south on County Route 662, which merges with U.S. Highway 130 south of Fieldsboro, to Roebling. Take Delaware Avenue west to Florence (Front Street) and follow River Road (County Route 656) south to Burlington City. Take a left on High Street and drive southwest on Burlington–Mt. Holly Road (County Route 541) and High Street again. Take a right on Washington Street (County Route 537) west through the Clermont section of Mount Holly. Drive north on County Route 541 Alt. and turn left on Rancocas Road, which runs to Timbuctoo.

ABOVE: *British forces briefly occupied Bordentown in 1778 and burned the homes of influential rebels. Retaining the iron railing from his original home, Colonel Joseph Borden returned after the war and built this house.*

RIGHT: *Still in use, the 1796 county courthouse in Mount Holly shows the state's Great Seal. The three plows in the shield pay homage to New Jersey's agricultural legacy. The figures supporting the shield depict Liberty and Ceres, the Roman goddess of grain.*

With a pause in gunfire, the commemoration of the 1777 Battle of Trenton features a salute to casualties, including Hessian Commander Johann Rall at his likely burial site in the First Presbyterian Church cemetery.

THE NORTH JERSEY SHORE
FROM BAYSIDE TO SEASIDE

ABOVE:
Trompe l'oeil depictions of an ice cream cone and cup of frozen ice on the Asbury Park boardwalk.

FACING PAGE:
The waters of the Shrewsbury and Navesink Rivers join the outflow from the Hudson at Sandy Hook Bay—where you can rig and soak your bunker chunks for trophy bass.

Comprising half of the state's land mass is Jersey's coastal plain, which is rarely over one hundred feet above sea level. The 127 miles of Atlantic Ocean coastline extend from the Atlantic Highlands and Raritan Bay to the Sandy Hook Peninsula, and continue south to the Cape May Peninsula. From here the coastline curves west and merges with the Delaware Bay. Along the Jersey coast is an almost continuous succession of barrier beaches that protect the bays and estuaries fed by countless rivers, streams, swamps, and lakes.

The Jersey Shore attracts millions of visitors every summer. Independence Day is usually the official signal that summer has begun, but many enjoy the fun in the sun on the Atlantic Coast all through June and into the month of September. There are numerous highly individualistic townships, cities, boroughs, and villages, each distinct in character from the other, all along the northern shore.

BAYSHORE VIEWS
EXPLORING RARITAN AND SANDY HOOK BAYS

ROUTE 17

From Keyport, take First Street to Stone Road (State Highway Route 39), and turn left on Florence Avenue to Union Beach. Take a right on Union Avenue, drive east on State Highway Route 36, and turn left on Laurel Avenue. Turn right on Beachway Avenue, which runs along the beach, to Main Street. Drive south and turn left on Port Monmouth Road (State Highway Route 7), which takes you back to the beach. Turn right on Church Street, left on Broadway, right on Main Street, and return to Highway 36 east. Take a left on First Street in Atlantic Highlands, then a right to follow Ocean Boulevard to Mount Mitchell Scenic Overlook Park. Continue on Ocean Boulevard and exit right just before the bridge into Highlands, then take an immediate right on Highland Avenue to Lighthouse Road.

There are several quaint communities along the silty beaches of Raritan and Sandy Hook Bays, both of which merge with the Atlantic Ocean at "the Hook." Keyport, at the mouth of the thickly grown Matawan Creek, is a quiet, turn-of-the-century town with a waterfront marina and dock, featuring panoramic views of Staten Island and Brooklyn. The Victorian bayside village has an old-fashioned downtown shopping area, whose main street is filled with antiques shops, old-time record stores, and restaurants that specialize in the preparation of local seafood dishes. One of the best of these is the Keyport Fisheries at 150 West Front Street, which has been serving the best fresh deep-fried codfish, shrimp, and scallops in the state since 1936. Set on a muddy finger of the Matawan Creek, this drive-in, take-out joint has a few tables, but the idea is to head to the nearest park or waterfront spot with a cardboard box of fried clams and a bottle of birch beer.

Keyport, Raritan Bay Beach, Cliffwood Beach, Union Beach, Port Monmouth Beach, Ideal Beach, Leonardo, Atlantic Highlands, and Highlands all front on the Raritan and Sandy Hook Bays. In recent times (since the Industrial Revolution) only a handful of bathers utilize the bayshore beaches, but the charm of old-time bungalows add to the interest of the area, and the Hudson River to the north has been much improved in recent decades, resulting in a cleaner aquatic environment. Union Beach, east of Keyport, has a remarkably moving September 11th memorial set right on the waterfront honoring the lives of those lost when the World Trade Center towers fell.

Keansburg is an old-style shantytown filled with trailers and makeshift homes, but it is most famous in New Jersey, and elsewhere, as an amusement-park destination. Since 1904, when the ferry boats arrived from New York City loaded with pleasure seekers, it was known as a great honky-tonk town for fun and games of all kinds. When asked about Keansburg, actress Ruby

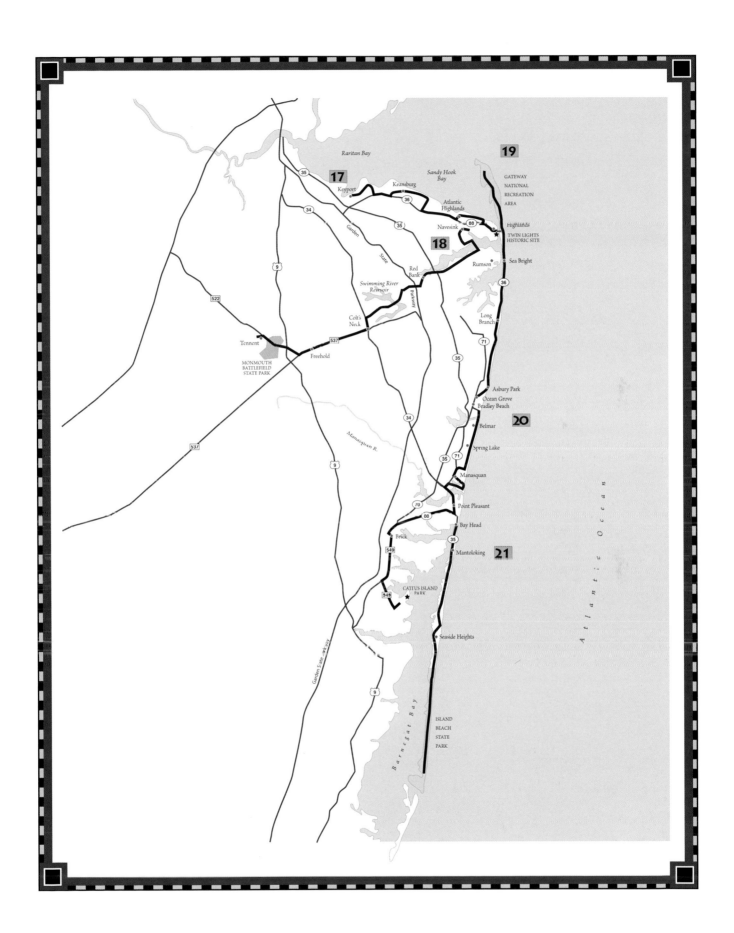

The Gothic Revival Navesink Twin Lights marking the entrance to New York Harbor take advantage of a high coastal promontory above the Navesink River and Sandy Hook Bay.

The Little Toot *of the Jersey Shore.*

*A batting cage at Keansburg
Amusement Park.*

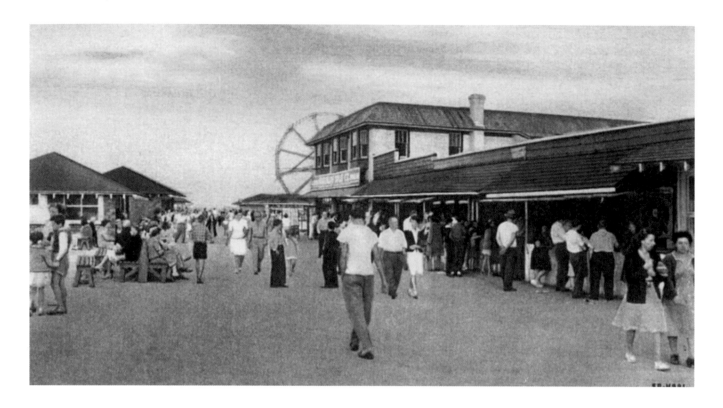

Keansburg has been called "Jersey's Coney Island." From the turn of the twentieth century to today, revelers have made the trip to this seaside destination to enjoy fun and sun.

Keeler recalled that when she was a chorus girl in New York during the Prohibition years, the Broadway crowd would often head there by steamboat after the speakeasies had closed. At Keansburg-by-the-Bay, flappers and their happy-go-lucky men friends attended all-night drinking parties 'til the dawn's early light. A gleam came into Ruby's eyes as she reminisced about the good old days in Keansburg, which she called Jersey's Coney Island.

Today, Keansburg is still a destination for families or singles on dates who want to ride a roller coaster or Ferris wheel as they view the beach and the bay. English-style French fries with vinegar and sea salt and an Old Heidelberg–style hot dog with hot relish are the foods to enjoy after a ride on the vintage merry-go-round. Cocktail and beer joints are raucous and fun for those seeking merrymaking. For a true Jersey Americana experience, Keansburg is just the place to go for relaxation and a few laughs. The tar, cement, and stone pathway along the yellow sand beach is filled with games of chance, rides, taverns, and eateries. This is a daytrip or nighttime place where the past seems to coexist with the present in an interesting and unique way.

The highpoint of the north shore is Atlantic Highlands in a drive to Mount Mitchell Scenic Overlook Park. It has spectacular panoramic views to the west, north, and east that include Staten Island, the Verrazano-Narrows, the Lower Manhattan and Brooklyn skylines, miles and miles of the south shore of Long Island, and the Sandy Hook Peninsula. At 260 feet above sea level, this is the highest natural point on the Atlantic Coast, from Maine to Florida. Coin-operated telescopes provide the best view at this spot on the highlands cliffs, which are dotted with splendid houses.

The Navesink Twin Lights are *the* landmark in the area, located on a high promontory above Sandy Hook and the outlet of the Navesink River. Completed in 1828, the original lighthouse was restored in 1862, and in 1898 it was the first major lighthouse to use electricity. The beacon from these double towers could be seen twenty miles out to sea. The lights still go on and off, but they are no longer used for navigation as the lighthouse was decommissioned in 1949.

Lying at sea level below Atlantic Highlands and the Navesink Twin Lights is the old-fashioned fishing village of Highlands. There is a good beach for a bay- and river-water swim, with water views of the Sandy Hook Peninsula. The downtowns of Atlantic Highlands and Highlands maintain a small-town ambience with sail, motor, and cruise boats in dock and plenty of seafood restaurants such as Bahrs Landing, a mainstay for many decades enjoyed by all who come to the Highlands–Sandy Hook area.

THE BIG SHARK ATTACK

Countless visitors flock to New Jersey's beaches every year, but the summer of 1916 brought one very unwelcomed guest to the north shore. That summer, a single killer shark made three separate attacks on swimmers on the Jersey coast and in freshwater Matawan Creek. The first occurred at Beach Haven at the southern tip of Long Beach Island. Shark-bite injuries resulted for several victims, with one person pronounced dead when pulled out of the Atlantic. The second attack happened up the coast at the north-shore resort town of Spring Lake, with one fatality. The predator continued up the shore, around Sandy Hook and into Raritan Bay, and then inexorably nosed upstream in fresh water for an incredible eleven miles to Lake Lefferts on the Matawan Creek, where it attacked a twelve-year-old boy who was swimming there. Witnessing this from the shore, another boy rushed into the water to rescue his friend. Both were killed. The violent attacks sparked a massive shark hunt up the Eastern seaboard, which resulted in the capture of a huge killer shark whose innards contained the human remains.

You can bet that visitors to the Jersey Shore thought twice about getting in the water after the shark attacks of 1916.

RIGHT: *Old Tennent Church served as a field hospital during the Battle of Monmouth, and Continental soldiers as well as a British lieutenant-colonel are buried here.*

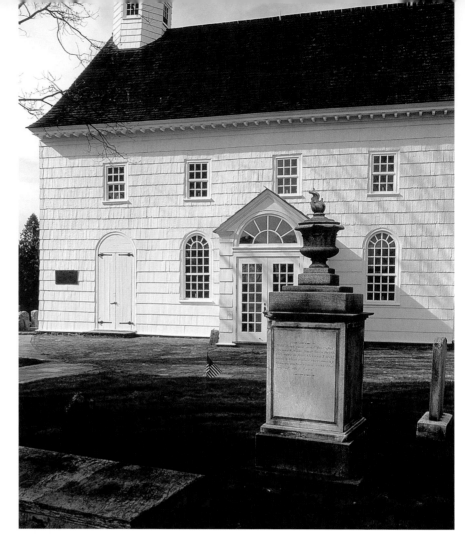

BELOW: *Royal Artillery re-enact the long cannonade that was central to the largest major battle in the northern colonies. It was here, at the Battle of Monmouth, that Mary Hays became part of the "Molly Pitcher" myth by helping her husband fight the British.*

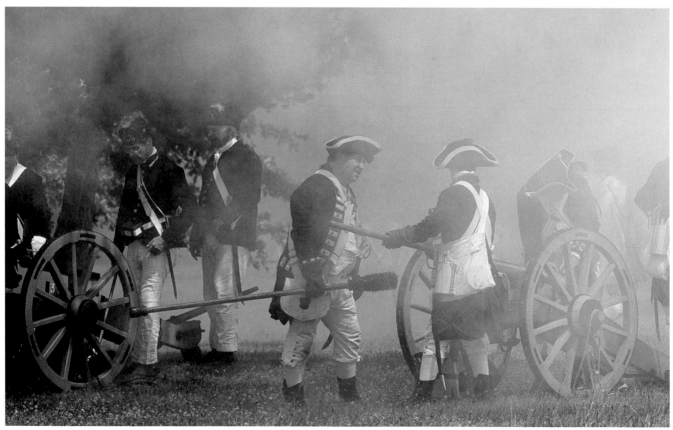

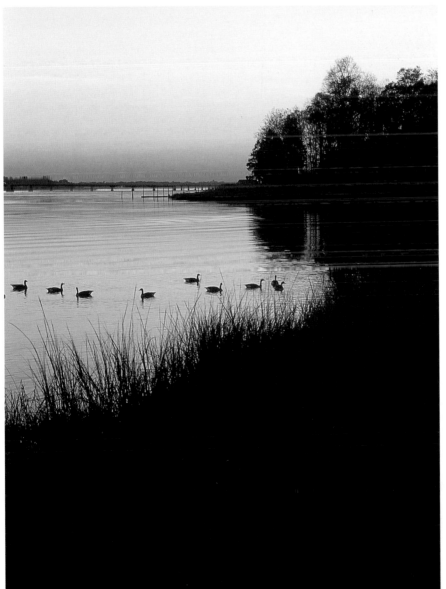

ABOVE: *At Battleview Orchards in Freehold, you can pick your own peaches and other fruits in season.*

LEFT: *Tidal waters like the Navesink River at Hartshorne Woods Park are crucial habitat for healthy fish stocks and other wildlife. They rely on fragile barrier islands for their existence.*

TOURING MONMOUTH COUNTY
FROM HARTSHORNE WOODS TO TENNENT

ROUTE 18

From Highlands, take State Highway Route 36 west to a right turn on Navesink Avenue to reach the Hartshorne Woods Park trailhead. Take Monmouth Avenue west and Browns Dock Road south to Huber Woods. Continue to a left on Navesink River Road and cross Oceanic Bridge to Rumson. Take the right on River Road, which will become Front Street, into Red Bank. Continue on Front Street across a bridge again to a left on Half Mile Road and a right on Newman Springs Road (County Route 520). Take a left on Phalanx Road to State Highway Route 34 south. In a mile, take the right (west) on Colts Neck Road (County Route 537). Continue on County Route 537 to Freehold, then take Throckmorton Street to Freehold-Englishtown Road (County Route 522) to Tennent. A right at the light will bring you to the Old Tennent Church.

Rivers lead away from the shore into the quieter farmland of historic Monmouth County. Not far from the busy beaches, the more peaceful town and country pace is found among the less developed fields, woodlands, and rolling hills.

Navesink Twin Lights sits on the Atlantic end of the line of cuestas, or glacial hills, that define the inland edge of New Jersey's outer coastal plain. The trails of Hartshorne Woods Park on the backside allow access to hikes on the rugged ridges and views of the Navesink and Shrewsbury Rivers. The birding is splendid. West of Hartshorne Woods, Huber Woods Park occupies the woods and pastures of an old farm overlooking the Navesink. A guide to native plants is available at the Environmental Center.

Cross Oceanic Bridge to Rumson, which is bordered by both the Navesink and Shrewsbury Rivers. An upscale summer resort in the nineteenth century, Rumson is now a wealthy enclave with large residences. One of the most famous residents here is Bruce Springsteen, who was born in nearby Freehold.

The red clay along the banks at the mouth of the Navesink River gave Red Bank its name. This is a town where the populace enjoys fishing and getting out in a boat. The marinas are filled to the brim with sea vessels, and in the winter when the river is frozen over, there are ice boat races, ice sledding, and ice skating. Red Bank is a rich cultural center for the region. The classic, streamlined diners downtown stay open late and attract hip, young folk who like to sit in the booths, sip sodas, wolf down waffles with ice cream, and listen to the jukebox. Three antiques emporiums occupy former Red Bank factories, and there are countless shops. The Count Basie Theatre at 99 Monmouth Street is in a converted 1926 movie palace. Named after the Count, who was born in Red Bank in 1904, it is a performing arts center that attracts a full roster of entertainment. In the mood to hit a jazz or rock 'n' roll club? Keep your eyes peeled—Bruce "the Boss" Springsteen has been known to show up for a set in this lively town.

After a bridge takes you across the Navesink River in Red Bank, the route continues up the watershed, crossing the Swimming River Reservoir, and leads to Delicious Orchards on Route 34 in Colt's Neck. The orchard was established at a time when local produce was regularly barged up the Navesink River to Sandy Hook on its way to New York City. Grab a shopping cart and stack it with fresh apple cider and homemade bread, pies, and donuts, as well as vegetables, fruits, cheeses, meats, nuts, and coffee—everything you need to fill the pantry or fridge. Twenty-six varieties of apples are featured in season, including the Jerseymac. After picking your fill, return to County Route 537 west toward Freehold.

The Battle of Monmouth was fought west of Freehold during a very hot, muggy day on June 28, 1778. The British suffered about four

hundred casualties in the battle—the heat killed almost as many as the "rebels." An American gunner's wife, Mary Hays, became one of the famed heroines of the Revolutionary War by helping her husband's short-handed gun crew. Another woman, who filled soldiers' canteens, took part in the battle and may be the legendary "Molly Pitcher" who followed her man over the bridge to attack the British grenadiers. When he was shot, she took up his gun and cartridges to bravely continue the fight.

Monument Park in old Freehold is where you can see "Molly Pitcher" sculpted in bronze at the base of the Battle of Monmouth Monument. At Monmouth Battlefield State Park, wayside exhibits commemorate Molly Hays' heroism. Every June, the famous battle is re-enacted in the park's 1,800 acres of woods, fields, hedgerows, and orchards. From the Old Tennent Church steeple, just west of the site, you can view the entire battlefield below. The church and the original copper weathervane are from 1751. After the battle, the Presbyterian church became a hospital for the wounded and dying, some of whom are buried in the churchyard.

The surrounding area is a flea-marketer's delight. The nearby Englishtown Auction marketplace, on Wilson Avenue, started as a country farmers' market in 1929, and by the 1950s it had become *the* spot for enthusiastic antiques hunters to find treasures at low bargain prices. In Englishtown itself, there is a huge indoor market with everything but the kitchen sink, and there are classic car competitions in the spring, summer, and fall seasons.

The old indoor and outdoor Collingwood Market and Auction on State Highway Route 33/34 is in a sandy soil and pine-tree setting just south of the U.S. Naval Weapons Depot. At this flea market you'll find authentic military outfits and accessories, comic books, home-cured pickles in barrels, fresh produce, an upholstery shop, a lamp rewiring shop, a pet shop, a cosmetics counter, jewelry, and candy, as well as counters for hamburgers, a platter of Jersey fresh eggs, and a decent cup of coffee. The people in Collingwood are just regular folk, and that is part of the good fun of it all. On a much smaller scale than Englishtown, Collingwood still holds its own in a very special way.

Farther south on County Route 547, the country town of Farmingdale is a true backroad kind of place, with historic buildings and a number of very charming and selective antiques shops. It is also where you will probably find some of the best of the open-air markets. Dealers will mention the small statue of a falcon that a lucky buyer purchased for $8 at a New Jersey flea market in 1993—it turned out to be the very one from the classic film *The Maltese Falcon*. Farmingdale was a stagecoach stop in colonial times that evolved into a commercial center for farming. In the summer, stop at the roadside farm stands where Jersey tomatoes, white sugar corn, and blueberries are choice. Some serve apple cider made from their own apples in their own mills.

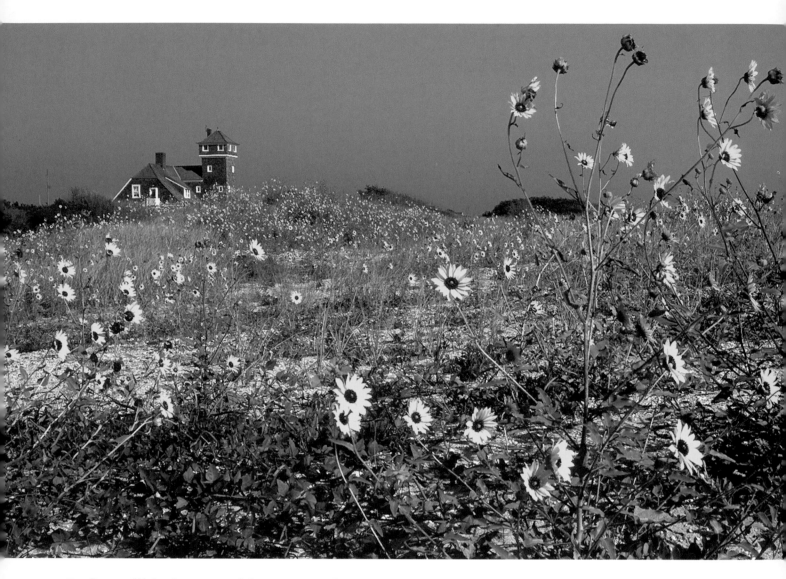

Sunflowers fill the dunes around the 1894 U.S. Life Saving Station, which is used for the visitors' center at Sandy Hook.

ABOVE: *A Sea Bright marina is peaceful in the soft light of a bayside dusk—the slender protection of the seawall nearby often fails to hold back surges during severe ocean storms.*

LEFT: *A day after this photo was taken, "Tillie" was carefully cut from the last standing wall of the old Palace Amusements in Asbury Park and trucked away for storage.*

RIGHT: *A summer breeze stirs the beach at Belmar.*

BELOW: *Dunes drift in the wind, sand shuffles in the surf, winter storms beat and break the shore, and the barrier beach very slowly migrates.*

Shingle-style, Georgian, Mission, Victorian, Carpenter Gothic—a place by the sea, at Spring Lake.

auditorium hosts entertainment events featuring the likes of the Glenn Miller Orchestra, doo-wop shows, and sophisticated New York cabaret performers such as K. T. Sullivan and Michael Feinstein. Sunday preachers sermonize here, and in the past these have included Dale Evans and Archbishop Fulton J. Sheen.

In 1976 Ocean Grove was listed as a historic district on the State and National Registers of Historic Places. "The Grove," as it is referred to by residents, is exactly that—filled with trees, lawns, and flower gardens that complement the hundreds of architectural treasures reflecting Victorian design attitudes. Gable roofs, turrets, finials, cornices, and newel posts adorn the gingerbread, clapboard-covered buildings in styles including Campground Cottage, Victorian Eclectic, Stick-Style, Queen Anne, and Colonial Revival. Wide-open porches and wicker rockers greet travelers at select hotels and bed and breakfasts, like the House by the Sea and the Quaker Inn, both of which offer travelers a hospitable and affordable respite from city and suburban life.

The township of Neptune, just inland, took over municipal control of Ocean Grove in 1980 and most of the quaint laws, like those governing automobile parking (Saturdays at midnight all cars had to get off the streets until after the Sabbath, which ended on Sunday nights), were rescinded. Liquor is still banned in the Grove, and you can't cavort on the beach on Sunday until after 12:30 p.m. Visitors are welcome at the Museum of the Historical Society of Ocean Grove on Pitman Street, where they can bask in the history of this great Victorian seaside resort town.

THE SEASIDE LIFE
FROM BRADLEY BEACH TO
CATTUS ISLAND COUNTY PARK

The seaside towns south of Ocean Grove each have a unique personality. Bradley Beach, which was named after real-estate developer James A. Bradley, is a congenial, family-friendly resort, while Avon-by-the-Sea is an upper-middle-class residential town. The boundaries of most of the eclectic towns along the north Jersey shore are marked by lakes formed by inland rivers. Only the Manasquan and Shark Rivers break through to the ocean, offering seagoing vessels deep inlets.

The dramatic Shark River Inlet separates Avon-by-the-Sea from Belmar. On the ocean side in Belmar, as you cross the bridge over the inlet, there is an old-style fishing pier, with a fishing club housed in a 1920s stucco building. Belmar is a commercial fishing port, with river and bay frontage, where you can join a party boat for a half-day of fishing at sea. Party boats operate all year and there are all-day fishing cruises and night cruises as well. Belmar's beaches attract the summer singles crowd and college jocks, and it has a gay beach between the pier and the inlet.

ROUTE 20

From Bradley Beach, follow Ocean Avenue (State Highway Route 18) south through Spring Lake, then a right and a left onto First Avenue (State Highway Route 49) into Sea Girt. Follow Highway 49 onto Washington Boulevard to State Highway Route 71 south. Take the first left onto Stockton Lake Boulevard, turn right and then left at the end onto Ocean Avenue. Turn right on First Avenue to Riverside Drive at Manasquan Inlet. Take Third Avenue north and turn left on Brielle Road, which becomes Fisk Avenue, to Highway 71 and go south again. Take State Highway Route 35 to Point Pleasant Beach, then State Highway Route 88 (Ocean Road) west to State Highway Route 70 south. Turn left on County Route 549, and right on Brick Boulevard (still County Route 549), which becomes Hooper Avenue. Turn left on Fischer Boulevard (County Route 549 Spur) and left on Cattus Island Boulevard to Cattus Island County Park.

Spring Lake, originally an Irish seaside resort community, is noted for its posh turn-of-the-century homes on the ocean and a tree-shaded park that surrounds a lake used only by swans. A church is on the lake, and a walk along the water's edge and over its rustic, wooden bridges is a restful experience for those in search of serenity.

On the north shore of the Manasquan River Inlet sits the town of Manasquan, once called Squan Village. This year-round community sees many family and college-student vacationers in the summer season. Brielle is also on the north shore of the inlet, one mile from the ocean. The town of Brielle attracts night and day party-boat fishermen who bring in blues, bass, and tuna.

Before a canal was opened between the Manasquan River Inlet and Barnegat Bay at Point Pleasant, the Manasquan estuary was almost all fresh due to the number of rivers and streams entering the intracoastal waterway, including the Metedeconk River, Kettle Creek, Cedar Creek, Oyster Creek, Forked River, Toms River, and Gunning River.

Known primarily as a family resort, Point Pleasant Beach has a lively, active boardwalk filled with bars, candy shops, pizza parlors, and games of chance. The town boasts many small bungalows, several motels—most right on the beach—and top seafood restaurants like Red's Lobster Pot Restaurant, which is situated right on the Manasquan River at the inlet.

Cattus Island has been a single parcel since 1690 when the proprietors for the Province of East Jersey divided the shore. It was a place for offloading the cargo of captured British ships during the Revolution. In 1895 John Cattus bought the land and used it as a pleasure retreat. The New Jersey Wetlands Act of 1970 halted planned construction in the area, and Green Acres funds were used by Ocean County to purchase the tract.

Part of the greater Barnegat Bay ecosystem, the over five-hundred-acre Cattus Island County Park is one of New Jersey's ecological gems, an excellent destination for a close look at New Jersey's famed wetlands. The

Sunbathers enjoy the warm rays and crashing waves at Point Pleasant Beach in this vintage postcard.

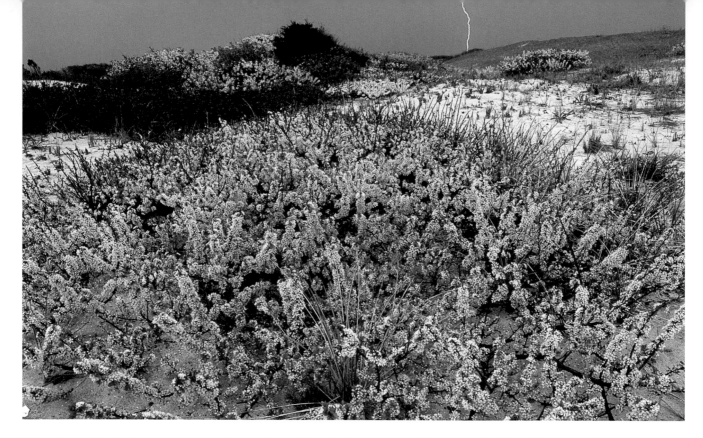

Lightning strikes in the temperamental coastal weather during the spring bloom at Island Beach State Park.

If the beach is too crowded, Cattus Island is a quiet retreat for a leisurely walk.

The maritime forest on Island Beach is but a remnant of a habitat that was once common along the East Coast. The plant diversity is significant as well as the shelter it provides to migrating songbirds.

Bath and guest houses like these "two miles at sea" in Seaside Heights, the nearest seashore resort to Philadelphia, were built when a "commutation ticket" was just forty cents per trip.

park has a 1,500-foot boardwalk and an extended viewing deck, as well as picnic areas. Here, you can sightsee, bird watch, and take a hike on six miles of public trail. The Swamp Crossing Trail is 0.4 miles, the Maritime Forest Loop is 1.7 miles, and the Hidden Beach loop is 0.7 miles. To see the park's more than three hundred plant species, penetrate the pine-oak forests on the numerous hummocks interspersed with Atlantic White Cedar swamps, freshwater bogs, maple-gum swamps, and tidewater salt marshes.

THE SANDBAR TOUR
BETWEEN BARNEGAT BAY AND THE OCEAN

ROUTE 21

Follow New Jersey Route 35 south from Bay Head to Island Beach State Park.

Twenty-seven-mile-long Barnegat Bay, the largest body of water in New Jersey, extends from Point Pleasant to Little Egg Harbor. The peninsula between the Atlantic Ocean and Barnegat Bay is a barrier beach, which is only two blocks wide at some points. In the winter the shallow bay freezes over; local residents can remember driving their trucks from the peninsula to the mainland over the thick, frozen ice. In the warmer seasons, this sun-drenched strip boasts some of the best white-sand beaches on the East Coast.

The splendid town of Bay Head is the last stop on NJ Transit's North Jersey Coast railroad line. Here, just west of Twilight Lake, the railroad tracks make a huge circle for the train's return north up the shore. Bay Head architecture is in the manner of the New England–Cape Cod style. The town's small, charming downtown area features upscale boutiques, clothing shops, an old boathouse now utilized as a small shopping center, Dorcas luncheon restaurant, and a German bakery called Mueller's that is the busiest business in town. The Victorian-style Grenville Hotel—only a half block from the ocean—has been meticulously restored, and also maintains a fine restaurant.

South along the coast on two-lane State Highway Route 35 is Mantoloking, an old Lenni Lenape Indian summering grounds, where the bay widens and the strip narrows. The houses along the oceanfront and bay front suddenly become gigantic mansions. Mary Roebling, of the Roebling Steel Company, summered here, as did Richard Nixon, Katharine Hepburn, and other celebrated, well-to-do personages.

After Mantoloking the road widens out and separates, with two lanes going south, two going north, and two short, road-bound blocks of small summer houses in between. Row upon row of summer homes abound in the tiny beach-bungalow communities of Normandy Beach, Silver Beach, Chadwick, Lavallette, and Ortley Beach.

Seaside Heights, a beach and boardwalk entertainment mecca with a top amusement park, is the primary Jersey-shore party town. The Casino Pier has the latest thrill rides, including the Super Himalaya, the Bobsled,

a splashy Log Flume, and other attractions all on a boardwalk-pier right atop the rolling waves of the ocean. An original 1880s Dentzel/Looff merry-go-round, with wood-carved, painted, and bejeweled horses grinding in up and down movement with tunes provided by a 1923 Wurlitzer military band organ, is the main attraction at the north end of the boardwalk. Funtown Pier at the other end features a newer merry-go-round and a Ferris wheel in which riders on high can take in the salt air, sea breezes, and a spectacular view of the boardwalk, the beaches, and the limitless expanse of ocean.

Located on the boardwalk in Seaside Heights for over fifty years, Maruca's Trenton tomato pies have been voted over and over the best pizza by New Jersey culinary experts. The Maruca twins have just franchised their "best in Jersey" pizza to other prime New Jersey locations. On the main boulevard, penny arcades and funky nightspots, with names like the Bamboo or Klee's Irish Pub, attract night revelers to this all-aglow magical resort town. Try a spinning wheel game-of-chance or check out Kohr's famous orange/vanilla custard twists, served with a cup of fresh-squeezed and iced Kohr's orangeade.

Seaside Park, nestled down the coast just below Seaside Heights, is a more sedate and quieter place in which to seek rest and relaxation at the beach. The boardwalk here is 1.7 miles long and is very simple, with old-fashioned Victorian, wooden gazebos that protect strollers from the sun or a sudden rain shower at convenient stop-point intervals along the way. The glowing white-sand beach in "the Park" is superb, having been called one of the best in the world by proud Jerseyites who summer here in the great, barn-sized beach houses.

The jewel of the Jersey coast and the pride of the state is the ten-mile-long Island Beach State Park—not really an island but a narrow, three-block-wide peninsula. Island Beach State Park is a drive-in recreation area for swimmers, fishermen, surfers, hikers, and birdwatchers. Red foxes, rabbits, and skunks hide in the deep brush in this remarkable nature preserve located between the ocean and Barnegat Bay. Osprey nesting poles can be seen periodically along the side of the narrow road, and cormorants, cranes, peregrine falcons, and even pelicans have been sighted gliding over the waves looking for fish. There are 2,400 parking spaces at the lifeguard-manned public access beaches, as well as bathhouses with showers and snack bars. Each September there is a wonderful Beach Plum Festival, when the beach plums are picked from the profuse bushes, cooked, and transformed into jam. At the very southern tip of the park, you can look across the swiftly running inlet and see "Old Barney"—Barnegat Lighthouse—which is at the northern tip of Long Beach Island, the eighteen-mile-long barrier-beach island just to the south.

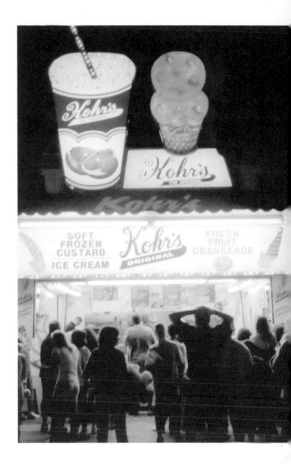

Kohr's refreshment stands are a familiar sight on Jersey Shore boardwalks. This popular Kohr's in Seaside Heights advertises their famous ice cream, frozen custard, and orangeade delights.
Photograph by Paul Eric Johnson

THE SOUTH JERSEY SHORE
SUMMERTIME BOARDWALKS AND WHITE-SAND BEACHES

ABOVE:

A new season awaits at Stone Harbor Yachts.

FACING PAGE:

As the treasure of 1950s Doo-Wop–style architecture in the Wildwoods gains renewed appreciation, custom cars and hot rods fill the streets and parking lots during the annual Boardwalk Classic Car Show.

Change is gradual traveling down the New Jersey coast. Voices carry accents of Philadelphia more than accents of New York—of the bayman and the whaler. Speech slows a bit just as southern plant and animal species mix increasingly with their northern cousins. Beach and bay grow greater in their contrasts. At the old railroad hotels of the Miss America pageant's former home in Atlantic City, casinos buzz with the noisy music of slot machines. The Wildwoods has rocked with hotrods and doo-wop motels since Dick Clark brought his American Bandstand there in 1957. And the Victorian "painted ladies" of Cape May help preserve its status as one of America's earliest shore resorts in the days of sail. It's all about fun and summer. The funneling effect of the peninsula's coastlines concentrates the migrating birds of the Atlantic flyway to create a quiet birder's paradise. Clouds of snow geese begin to arrive at the Brigantine salt marshes in late October. It's all about fish, mussels, and fiddler crabs. And periwinkles.

OLD U.S. HIGHWAY 9
THE ROAD TO TUCKERTON

ROUTE 22

From Island Heights, take State Highway Route 37 west to the jug-handle exit for Washington Street to Toms River. Take a left on State Highway Route 166 to U.S. Highway 9, and drive south to Manahawkin. Take a detour to Long Beach Island by following State Highway Route 72 east across Manahawkin Bay; head north on Long Beach Boulevard (County Route 607) to Barnegat Lighthouse State Park. Reverse direction and return to U.S. 9, following it south to Tuckerton.

Your trip down the southern shore begins at Island Heights, a gracious hilltop community where Toms River enters Barnegat Bay. This serene town, with its majestic, tall trees and spacious gardens, is a former Methodist campground with stunning Victorian and Arts and Crafts–style mansions and bungalows. It is also home to the Ocean County Artists' Guild, housed in an old mansion at 22 Chestnut Avenue. This woodsy, rustic spot is the place to be on a night when the August moon turns from red-orange to yellow to white, reflecting onto the still waters of Toms River. From the bluff are views of Barnegat Bay, Seaside Park, Island Beach State Park, and the Atlantic Ocean. In addition, there is a charming small-scale boardwalk with benches and a restored nineteenth-century fishing gazebo and pier on the river waterfront.

The Ocean County Historical Museum in the town of Toms River is at 26 Hadley Avenue and maintains a unique collection of Native American relics and Revolutionary War mementos. During the Revolution, the British attacked the blockhouse at Toms River, burning the town and executing the patriot leader John Huddy. Huddy Park is named in his honor.

South on U.S. Highway 9 the great Jersey Pine Barrens stretch west, dotted with forgotten villages, abandoned nineteenth-century iron-bog mining towns, and thousands of acres of pine trees, frog ponds, rivers, creeks, and streams. Covering an area over 1,000 square miles, the Pine Barrens have a core of 650,000 acres, under which lies the largest natural aquifer on the East Coast, equivalent to a lake 75 feet deep. Local landmarks are the Forked River Mountains, two geological formations rising to 184 feet above sea level. The entrance to the State Game Farm is on the bayside; watch for the ornate iron gates and make a left turn. The Forked River flows into Barnegat Bay here, where the Forked River State Marina is located. Also check out the original 1950s rocket-ship-style Forked River Diner on old U.S. 9 for eggs, bacon, and a cup of coffee.

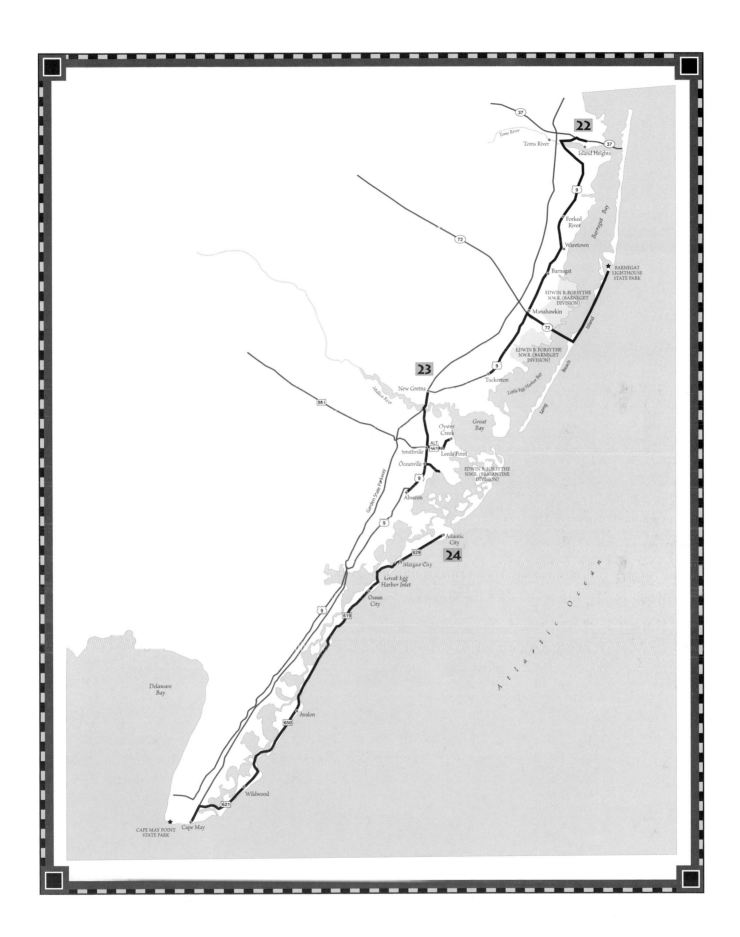

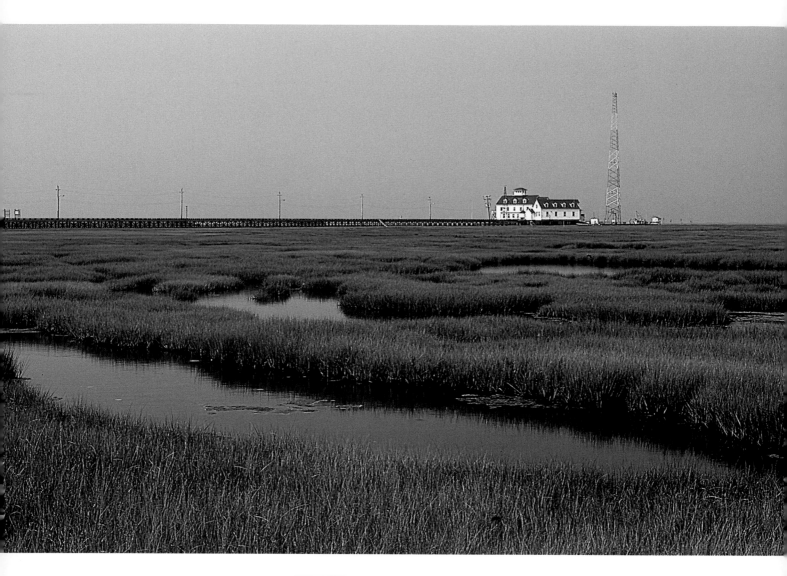

ABOVE: *Located in a former U.S. Coast Guard station, the Rutgers University Marine Field Station at Great Bay conducts research in one of the cleanest estuaries on the East Coast.*

RIGHT: *The striped bass or bluefish are in, blue crabs are abundant, and the bayside is a paddler's paradise.*

ABOVE: *This bayman's screen house—a protection from greenhead flies—on Mott's Creek is near Leed's Point, the legendary birthplace of the Jersey Devil.*

LEFT: *In August, fine salt hay in swirled mats is bordered by thick cordgrass and misted with sea lavender; in September the flats are streaked with scarlet glasswort; by November, thousands of snow geese arrive at the salt marsh.*

Next along your route is the town of Waretown, whose first settlers in the early 1700s were whalers. Later they constructed sawmills, and boat-building became a big local industry. Wells Mills County Park, just a few miles west of town on Wells Mills Road (County Route 532), is nine hundred acres of unique habitats. There are streams, bogs, swamps, and majestic cedars, as well as an upland pine-oak forest and a freshwater lake. Rare plants include turkey beard, grass pink, snakemouth, and bog asphodel. There are 16 miles of marked hiking trails ranging from 0.3 to 8.4 miles. Every October at Wells Mills County Park, down-home melodies are played out at the Pine Barrens Jamboree, which celebrates Jersey Pines music, crafts, nature, history, and vittles.

Barnegat is on the western edge of Barnegat Bay at a point where it is over six miles wide. A port community founded in 1664, it became a resort destination in the nineteenth century. The town center now has antiques stores and the Hurricane House Ice Cream Parlor, which was established by two sisters in the 1920s. The road connecting Barnegat to the bay passes Friends Meeting House and Barnegat Village, which is a Lilliputian assemblage of old shacks, stores, and houses put together to resemble a tiny town circa 1840. The Barnegat and Brigantine divisions of the Edwin B. Forsythe National Wildlife Refuge cover over 43,000 acres of coastal habitat. Protected are over 10,000 acres of estuary, woodlands, and barrier dunes. It is on the Atlantic flyway, and migratory birds here include American black ducks and Atlantic brant, which depend on the Jersey Shore's remaining bay wetlands for their survival.

The Lenape camped at Manahawkin, whose name is thought to be derived from the words for "good corn-land." There is a fine cranberry bog in the center of town, with surrounding pine trees, picnic tables, outdoor fireplaces, and a sandy beach. Swimming is allowed during lifeguard hours. After swimming in a cranberry bog, you may come out red, but don't worry—it's said to be a health tonic for the skin.

Manahawkin is the jumping-off point to Long Beach Island, an eighteen-mile-long barrier beach separated from the mainland by Barnegat Bay. Though Old Barney has not been in use on Barnegat Inlet since 1927, the more than century-old lighthouse stands at the northernmost point of the island as the centerpiece of Barnegat Lighthouse State Park. Stretching along the island are several seashore resort towns with a combined year-round population of about twelve thousand and a summer population ten times that. They include Barnegat Light, Loveladies, Harvey Cedars, Surf City, Ship Bottom, Brant Beach, Spray Beach, Beach Haven, and Holgate, which rests on the Beach Haven inlet at the southern section of the extensive Forsythe refuge.

Set on Little Egg Harbor Bay, Tuckerton was designated the Third Port of Entry of the United States by George Washington in 1791. Tuckerton became a railroad town in the nineteenth century, when cars hauled cranberries and sea grass out of the New Jersey village. The Tuckerton Railroad ran for over sixty years but was abandoned in the 1930s. Today, highlights of the town are the Barnegat Bay Decoy and Bayman's Museum and the Tuckerton Seaport. Don't drive past the Stewart's Root Beer drive-in on the road across from Lake

Pohatcong. Order a hot dog special and a cold ice-boxed frosted mug of root beer, and they will be delivered right to your car just like in the 1950s.

The two-lane Great Bay Boulevard, often only one-and-a-half lanes, runs south from Tuckerton, traversing the center of the Great Bay Boulevard Wildlife Management Area and crossing low bridges over the limitless marshland that stretches in all directions. The road ends at the ocean where you must make a U-turn to drive back inland. Little Egg Harbor is on the north, and Great Bay, where the Mullica River joins the ocean, is on the south.

JERSEY DEVIL COUNTRY
NEW GRETNA TO ABSECON

The backroads surrounding New Gretna run deep through Pine Barrens cranberry and blueberry country. During the summer months, keep an eye out for the roadside farm stands that sell the best berries Jersey has to offer.

The Mullica River is the third largest watershed in the state. The view from the bridge where the river flows into Great Bay is breathtaking. Eastward lie estuaries to the Great Bay and the Atlantic Ocean horizon, dotted with ramshackle fishing huts and white egrets. Westward, the lazy river meanders out of what looks like a primeval wilderness extending as far as the eye can see. Here, U.S. Highway 9 is closed, and alas, you will be re-directed via signs to the Garden State Parkway, which is the only way to cross the river. Your first right, immediately after crossing, will bring you back onto old U.S. 9.

Once on the south bank of the Mullica River, U.S. 9, also known for a stretch here as New York Road, takes you along the western boundary of the Brigantine Division of the Edwin B. Forsythe National Wildlife Refuge, passing Motts Creek at Higbeeville and continuing on to Smithville. On Lake Meone, the colonial village of Smithville, which was restored in 1952, is a potpourri of shops and restaurants, and is good for a short rest and walk. But, beware—you're entering Jersey Devil country, and he awaits your arrival with a pitchfork and a forked tail that will sting!

At Leeds Point—which is on the Great Bay, Little Bay, and Reeds Bay, and surrounded by marshland and waterways in the Edwin B. Forsythe National Wildlife Refuge—the Oyster Creek Inn is a place where seafood dinners can be an adventure. It offers a clam stew served with a Jersey Devil cocktail (cranberry juice and vodka) at a bar in the shape of a ship. A few of these devilish concoctions have been known to produce an apparition of the red-eyed devil himself. Take a walk alongside the fishermen's shacks on the bay in the moonlight after your meal. Like a red-glowing mirage in the distance to the south, you can see Atlantic City—the great gambling mecca. Could Atlantic City be another town that was invaded by the spirit of the impish Jersey Devil, who is always in search of some new mischief-making or treachery?

Proprietors of the Smithville Inn, Ethel and Fred Noyes—who created the old-time town of Smithville by moving in yesteryear buildings and shacks that were rented to storekeepers—also built the modernistic Noyes Museum of Art

ROUTE 23

From New Gretna, follow U.S. Highway 9 south to the Mullica River; get on the Garden State Parkway to cross the river, then return to U.S. 9. In Smithville, take a left at the cemetery on East Moss Mill Road (County Route 561 Alt.) to Oyster Creek Road to Leeds Point. Return to U.S. 9 and continue south to Absecon.

ABOVE: *Some of the older hotels along Cape May Beach have been converted to condominiums.*

RIGHT: *A National Historic Landmark, Lucy the Margate Elephant is a roadside monument to the late-nineteenth century hucksterism that was used to attract visitors for land sales. It is now a tourist shop and museum.*

Fun in the summertime at Ocean City Beach. The great Flanders Hotel is on the right.

Classic signs are a legacy of the Wildwoods' history.

As seasons pass, ocean tides add sand to this beach, and as it grows into the sea, the old lifeguard stands in Ventnor City are left behind.

in Oceanville. This museum displays their collection of early American quilts, folk art, craftworks, and art. Rotating exhibits often featuring New Jersey artists, like Stephen Hooper of Clifton, are an attraction at the museum, as are the craft and antique markets, concerts, and the museum shop. Two miles south of Smithville, the Noyes Museum is just off U.S. 9 on Lily Lake Road.

For birdwatchers, you won't want to miss the eight-mile Edwin B. Forsythe National Wildlife Refuge Wildlife Drive over dikes to the middle of the salt marsh. More than 250 bird species visit here each year, so just continue down Lily Lake Road to the entrance.

U.S. 9 passes through the center of Absecon, which lies on a low bluff above the estuaries. Here, you will see old-style motels where some travelers prefer to stay rather than the ones in nearby Atlantic City itself; but take care—many of these rent only by the hour. Others, however, are just fine. One excellent 1950s motel just north of Absecon called the Ten Acres is set in a pine grove where at night you can enjoy the sound of a hoot owl combined with the soft, repeated cry of a whip-poor-will—just the sound to lull the weary traveler into a deep sleep.

THE LEGEND OF THE JERSEY DEVIL

Leeds Point, situated between the mysterious Pine Barrens and the powerful Atlantic Ocean, is said to be the exact spot of the fantastic birth of the Jersey Devil. The myth of the Jersey Devil, a creature that is said to dominate the southern region of New Jersey, can be traced back to an evening in 1735. On that dark night, a Mrs. Leeds gave birth to her thirteenth child, who was apparently transformed through some kind of sorcery into a horned and forked-tailed demon. Just following the birth, little feet suddenly became hooves, bat-like wings sprouted out of the child's shoulder blades, and the baby's face developed into an elongated, hairy horse's snout. The beast then grew in size almost to that of a full-grown man. According to Jersey Devil lore, the hungry beast may have devoured the entire Leeds family that terrible night, including Mrs. Leeds and her twelve sleeping children.

Other dreadful tales abound regarding the mean-spirited, red-eyed monster that continues to play devilish tricks on the local "Pineys," as well as on the visitors to the region, many of whom claim to have either encountered or been walloped or severely beaten by him. There is little doubt among true believers that this creature still makes his home somewhere in the Great Pine Barrens wilderness. The devil has been seen as far north as the Great Swamp at Chatham and in Morristown, but has been spotted most often flying over his birthplace, Leeds Point. Drivers are advised to watch out as they travel down old U.S. Highway 9 through the Pine Barrens or off onto the sandy backroads. "You never know when the Jersey Devil is going to strike a blow," Pine Barrens inhabitants flatly warn. "He will appear suddenly and without warning in the night."

ROUTE OF THE GULLS
OCEAN DRIVE FROM OLD ATLANTIC CITY
TO CAPE MAY

It has been said that, like Mecca, all roads lead to Atlantic City. Millions descend upon this legendary place to the gambling casinos built alongside the great boardwalk, the first seaside wooden walkway in the world, built in 1870. There was a time when Atlantic City was known primarily as a great continental summer destination, America's answer to the French Riviera. Ideally situated on a sandbar and surrounded by natural areas of salt marsh and tidal flats, Atlantic City is warmed by gulf-stream currents and protected from harsh northeasterly storms.

Two magnificent hotels, like great sandcastles on the ocean, were once the main attraction in old Atlantic City: the Marlboro-Blenheim Hotel and the Hotel Traymore. When Atlantic City became a Las Vegas–type gambling town in the 1970s, the luxury hotels were most unfortunately demolished. The Atlantic City Historical Museum, on the old Garden Pier jutting out into the ocean off the boardwalk at New Jersey Avenue, has special exhibits documenting the greatness of Atlantic City's past.

The Knife and Fork Inn, at Atlantic and Pacific Avenues since 1912, was featured in the movie *Atlantic City* starring Burt Lancaster and Susan Sarandon, and it has been recently restored. But it is a neon-bedecked Arctic Avenue spot where celebrities stop for a bite: the famous White House Sub Shop. Since 1946, it has served mouth-watering submarine sandwiches on home-baked loaves to the public. Here, you'll find photos of the likes of the Beatles (all four), Tiny Tim, or Liberace chewing away on a White House Special sub. For such non-franchised, non-compromised quality and expertise, a line often winds out the door of this original location at lunchtime.

On the way out of Atlantic City, you will see one of the greatest treasures in the annals of American roadside attractions: Lucy the Margate Elephant. Built in 1881 by a Philadelphia developer named James V. Lafferty, the wooden elephant was initially meant to attract real estate investors. Inside Lucy, whose body circumference is eighty feet, an office and a restaurant were once housed where prospective buyers could gaze at the ocean and dream of building a home in that seaside region. From the ground up, the grey pachyderm is almost as tall as a six-story building. It has seventeen-foot ears, twenty-two-foot tusks, and a twenty-six-foot tail. The structure is a timber box frame to which almost a million specially curved wood pieces were added and finally sheathed with twelve thousand square feet of tin. Lucy stands today by the ocean in Margate as a museum, thanks to a group of concerned "Save Lucy" citizenry who raised money to reconstruct her in 1973 after she was moved two blocks south to the present location.

Ocean City has been a wonderful, old-fashioned seaside town since 1879. Like Ocean Grove, it is a dry town, but the atmosphere and the attractions on its two-and-a-half-mile boardwalk are lively. Though it has some amusements to offer, the boardwalk is noted for its Music Pavilion, built in 1912, where live bands continue to play songs of yesteryear at free concerts during the summer.

ROUTE 24

From Atlantic City, take Atlantic Avenue and Ventnor Avenue (County Route 629) south to Somers Point Boulevard. Drive over the bridge (Ocean Drive), then take the right jug-handle onto Ocean City–Longport Boulevard and cross the Great Egg Harbor Inlet. Take Wesley Avenue through Ocean City and onto Central Avenue (County Route 619). Take a right and a left at the end onto Ocean Drive to cross Corson Inlet into Strathmere (County Route 619 becomes Commonwealth Avenue, then Landis Avenue), and continue across Townsends Inlet to Avalon, where Ocean Drive becomes County Route 650. Continue to Stone Harbor on County Route 650 (Third Avenue), cross the bridge (Ocean Drive) to Nummy Island, then drive across Hereford Inlet into North Wildwood on State Highway Route 147. Continue south on County Route 621 (New Jersey Avenue, then Pacific Avenue, then Ocean Drive). At the end, turn left on State Highway Route 109 (Lafayette Street) into Cape May.

Black skimmers use undeveloped beachfront as nesting grounds during the late spring and summer. They are an endangered species in New Jersey.

The gazebo at Corbin City's town park is located on the Tuckahoe River. The Tuckahoe Wildlife Management Area extends from here north to the Great Egg Harbor River.

ABOVE: *The preservation of Cape May's Victorians is no accident. The bulldozers and wrecking balls were closing in until a survey revealed the true wealth of this unsurpassed collection.*

LEFT: *The Cape May Peninsula is one of the world's top birding spots. You can obtain a field guide at the Cape May Bird Observatory, join the Hawk Watch at Cape May Point State Park, or walk the dunes and meadows of the Cape May Migratory Bird Refuge.*

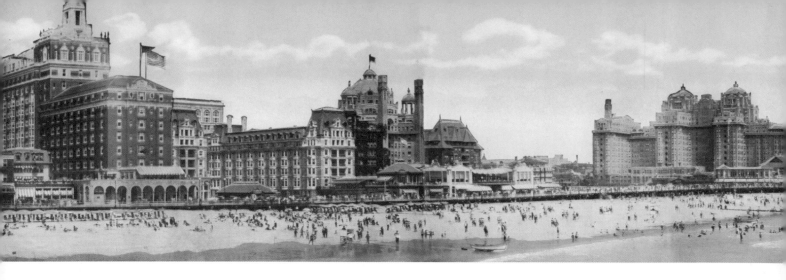

Irish-Catholic Ocean City, like Spring Lake on the North Shore, attracts an aristocratic set, particularly at the Flanders Hotel, built in 1923, for those who like to rest and dine in high style. Grace Kelly summered in Ocean City, and returned with her family even after she became Princess Grace of Monaco. The city itself is a thriving resort with many hotels, motels, and excellent seafood restaurants. Here, the attitude is centered on good behavior, serenity, and modesty, and there are some lovely mansions to see at the north end.

The barrier island sometimes referred to as Seven Mile Beach is where the beautiful south-shore beach town of Avalon lies, with its oceanfront homes set on pristine, well-maintained dunes. The high, protected dunes of Avalon are a sight to behold. The World Wildlife Fund maintains ten thousand acres of marshland here, which is a guarantee to homeowners that this land will not be available to developers in the future. The Wetlands Institute, located on Stone Harbor Boulevard in Stone Harbor, is a thirty-four-acre bird sanctuary in the middle of the six-thousand-acre Marmora Wildlife Management Area. Throughout the salt marsh, osprey and snowy egret sightings are common.

Wildwood-by-the-Sea, which advertises itself in brochures as "five miles of health and happiness," is a jazzy, teeming resort. Along the three sections of the town—North Wildwood, Wildwood City, and Wildwood Crest—there are 1940s and 1950s Miami Moderne–style stucco and neon-outlined motels, brand-new motor inns, grand oceanfront hotels, and over one hundred restaurants. Summer tramways will carry you along the boardwalk from North Wildwood to Wildwood Center. The four-mile-long boardwalks contain several amusement piers with every kind of wild ride imaginable, including water parks, a giant 150-foot-tall Ferris wheel, tilt-a-whirls, and dodgem cars. Morey's Pier on Spencer Avenue has the largest roller coaster in the state, called the Great White, which features a one-hundred-foot drop to the beach.

Unique to Wildwood is the Doo Wop Preservation League, established to save the remaining 1950s motels and hotels featuring jutting balconies, glitzy neon, fake palm trees, and aquamarine, kidney-shaped swimming pools. More than one hundred of these places have steadily been demolished, but there are enough of them left—about fifty, with names like the Satellite, the Lollipop, the Bel Air, the Ebb Tide, and the Ala Moana—to give the town a chance at being named a new historic preservation district, much like the one

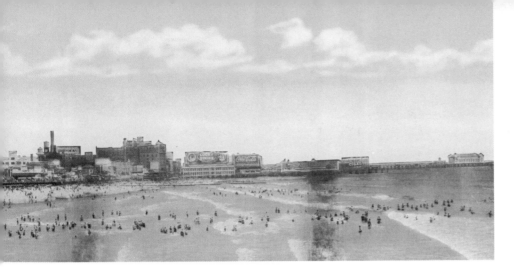

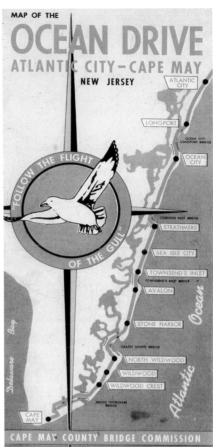

The Ocean Drive from Atlantic City to Cape May offers views of the shore as it takes you to the southern tip of New Jersey. This vintage map advises travelers to "Follow the Flight of the Gull."

in Miami Beach. Vintage 1950s classic American cars converge at Wildwood all summer long, and the motto here is "Fifties Forever!"

The seashore city of Cape May is at the southernmost tip of the Cape May Peninsula, where the Delaware Bay meets the Atlantic Ocean. The first seaside resort to be designated a National Historic Landmark (in 1972), Cape May is famous throughout the world for its Victorian architectural treasures. Between the American Revolution and the War of 1812, the cape was an out-of-the-way retreat shared by the last of the Lenape tribes and seafaring colonists. In 1853, the great Mount Vernon Hotel was built on the Cape May beachfront. From 1840 to 1910 Cape May came to be known as the queen of seaside resorts, eventually to be succeeded by Atlantic City to the north with its grand boardwalk and much bigger luxury hotels. Presidents Lincoln and Grant, as well as Senator Henry Clay, vacationed in Cape May homes and hotels, some of which are still standing today.

The Cape May Migratory Bird Refuge—off Lafayette Street on Sunset Boulevard, just past Bayshore Road—is an important stopover on the Cape May Peninsula for migrating birds and habitat for endangered raptors, such as the peregrine falcon and Cooper's hawk. The *New York Times* called the southern tip of New Jersey at Cape May one of the world's top birding spots during the autumn migrations, the peak weekend usually occurring in late October. Pete Dunne of the New Jersey Audubon Society, who has counted 1.5 million robins and 45,000 scooters a day during this annual migration, called it one of the world's most dramatic spectacles: "You can see a sky so crowded with swallows, it reduces the amount of sunlight coming to the earth. . . . This is the way North America used to be."

The sturdy Cape May Point Lighthouse at the end of Lighthouse Avenue was built in 1859, stands 157.5 feet high with walls 8.5 feet thick, and sends a beacon of light visible 24 miles out to sea. During the long and lazy summer season at Sunset Beach—the southernmost tip of the state in Cape May Point, located at the foot of Sunset Boulevard—the American flag is lowered every night at dusk, taps is played, and people gather to watch the sunset. Here, there is a one hundred percent un-obscured horizon line, and the spectacular sunsets are caused by atmospheric conditions created by the meeting of the Delaware Bay and the Atlantic Ocean.

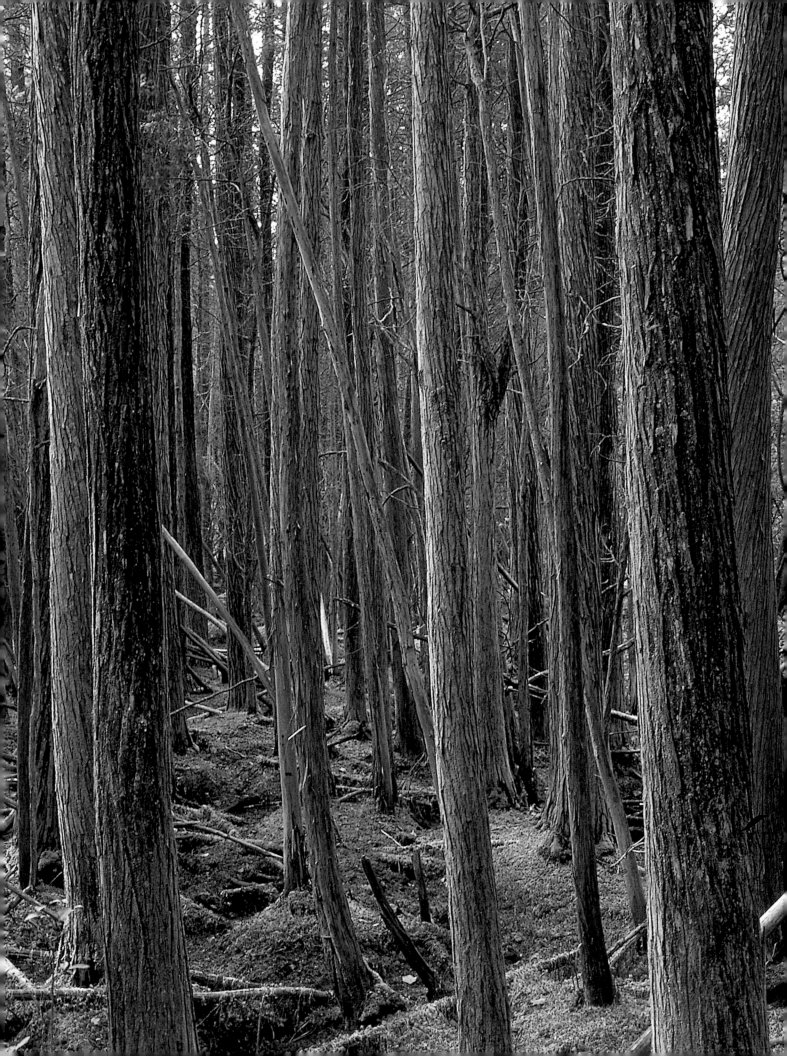

THE PINE BARRENS AND DELSEA REGION
SECRETS OF THE GARDEN STATE

Frequent fire reduces shrub cover to favor the Pine Barrens heather typically found on sandy sites in the Pygmy Pines.

Atlantic white cedar forests were heavily exploited for shipyards on the coastal rivers. When Europeans first saw them, some trees were six feet at the base and a thousand years old.

At over a million acres, the great Pine Barrens region of New Jersey is the largest wilderness east of the Mississippi River. It features two thousand square miles of pine and oak forests; cedar swamps; bogs; tea-colored, fish-filled rivers and streams; ocean, bay, and river estuaries; rare plants; native animals; and migratory birds. South and west of the Pine Barrens lies an area that slopes to the shores of the Delaware Bay and River called the Delsea Region—where the Delaware River meets the sea. Coastal wetlands attract wildlife here, and there are dozens of large natural areas and bird sanctuaries. This is the most fertile region in New Jersey, earning it the nickname "the Garden State." Both Delsea Region and the Pine Barrens are steeped in history, going back to the early Native Americans who utilized the land's abundance before the earliest European settlers landed on its marshy shores.

AMONG THE PINES
LAKEWOOD TO PENN STATE FOREST

ROUTE 25

From Lakewood, take County Route 526 northwest to Bennetts Mills. Turn left on Van Hiseville–Bennetts Mill Road (County Route 636) to Van Hiseville, and follow Route 528 to Cassville. Drive south on Cassville–Toms River Road (County Route 571) and turn right on Lakehurst-Whitesville Road (County Route 547). At Lakehurst, take State Highway Route 70 west. Diverge right onto County Route 530 and Whites Bogs Road, then return to Highway 70 and continue west. Just past the entrance to Brendan T. Byrne State Forest, go around Four Mile Circle to take State Highway Route 72 south.

Go right on County Route 563 south to Chatsworth, continuing past processing plants and into the cranberry bogs. In Speedwell, take the small paved road on the right—it will become unpaved—to the T-intersection at Friendship. Return to County Route 563 south and look for a left turn onto Lake Oswego Road to reach Penn State Forest.

Nestled on the northern edge of the Pine Barrens, the town of Lakewood became the first winter health resort in the United States. The pine trees attracted wealthy and socially connected guests who came to stay on the gracious estates built by in-the-know millionaires. In 1880 the Lakewood Hotel opened on fourteen acres of well-maintained land, attracting such luminaries as Grover Cleveland, Oliver Wendell Holmes Sr., Rudyard Kipling, and Mark Twain. The old-money Vanderbilts and Astors stayed at another vast hotel, the luxurious Laurel-in-the-Pines. Unfortunately, both of these hotels were torn down in the 1960s. George J. Gould, the son of a railroad magnate, built his estate in Lakewood in 1898; today it is the splendid Georgian Court University. Located on Lakewood Avenue and Ninth Street, it is run by the Sisters of Mercy who bought the mansion and its grounds in 1930.

The town flourished in the 1920s and 1930s when there were a hundred hotels all along U.S. 9 and the town's backroads. Families enjoyed the fresh, pine-scented air while sitting on the front porches at high noon. Basking in the sun on a cold winter's day, many of the women dressed to the hilt in fur coats, rhinestone-studded dark glasses, and diamond brooches, necklaces, bracelets, and rings that glistened in the sun. Also dazzling on U.S. 9 in Lakewood is the Moon Motel's striking, super-size neon sign that includes images of a crescent moon, shooting rocket ships, and the planet earth. This is pop culture and Industrial Art neon-sign sculpture at its best.

As you drive into Rova Farms in Cassville, you will see above the trees the gleaming, gold domes of St. Vladimir Russian Orthodox Church, which sits on a hilltop overlooking the deep, black Lake Rova and the surrounding woods. Rova Farms was founded in 1934 on 1,400 acres owned by three thousand Russian shareholders. At an enormous bar in the building by the lake, Russian vodka was the main drink of choice, and the restaurant served pelmeni, borscht, and roast pork with spaetzle and sauerkraut—just as if you were in Old Russia before the revolution. Today,

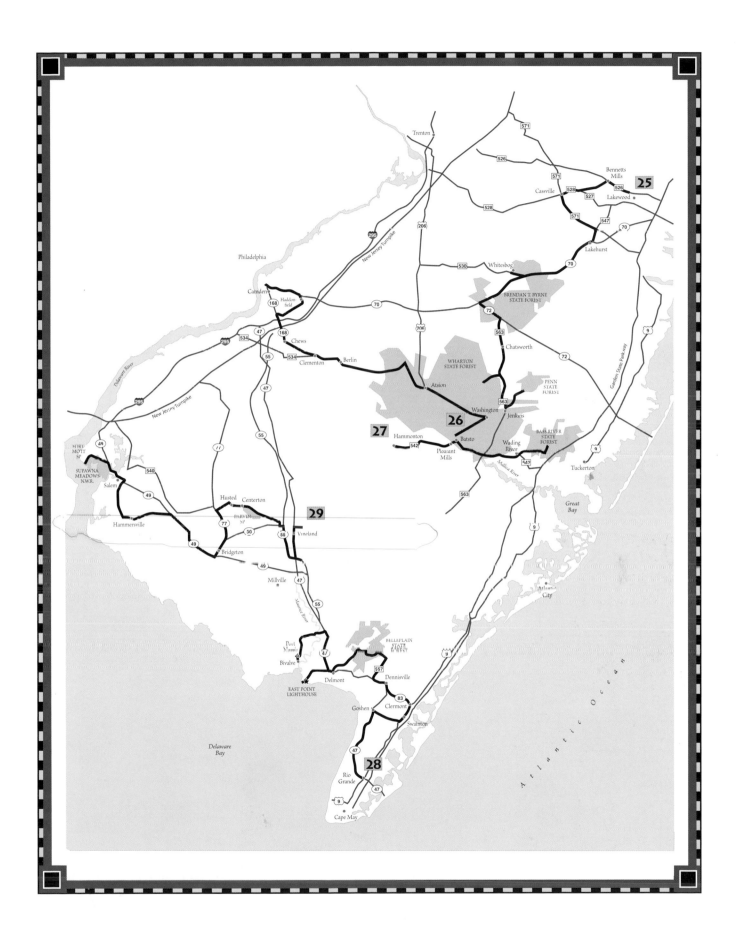

The pavilion at Pakim Pond in Brendan T. Byrne State Forest was built by the Civilian Conservation Corps in the 1930s. It was once the site of the Lebanon Glass Works, which shut down in 1867 due to depletion of the wood supply.

For more than a century, October has been harvest time at the Pine Island Cranberry Company in Chatsworth—the unofficial capital of the Pine Barrens.

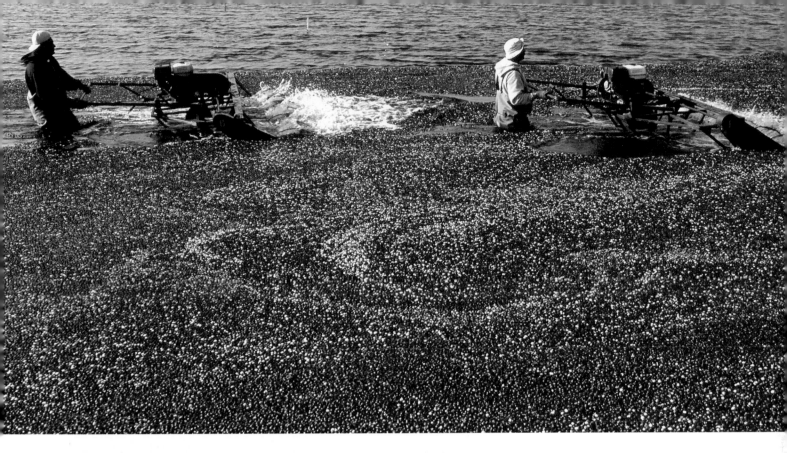

ABOVE: *A water reel stirs loose the ripe berries of a flooded cranberry bog. The fruit floats and is easily gathered, but wet harvesting has made small, old, irregularly shaped bogs obsolete.*

LEFT: *Travelers driving by on Route 9 cannot miss Lakewood's whimsical Moon Motel, with its distinctive neon sign.*

Attracted by the healthy air of the Pine Barrens, wealthy patrons frequented several luxurious resorts in the Lakewood area. This vintage postcard depicts the Laurel-in-the-Pines hotel.

Zeppelins often touched down on the flat grounds surrounding Lakehurst, as shown in this vintage postcard. It was at Lakehurst that the Hindenburg disaster occurred, as the great flying ship burst into flames just seconds before landing.

you can buy shares in Rova, go to the flea market (on Tuesdays), and visit the bar.

Colliers Mills Wildlife Management Area is a vast wilderness, with twelve thousand acres of pitch pine and scrub oak interspersed with fields and wetlands. Red headed woodpeckers, eastern bluebirds, Cape May warblers, wrens, yellow-bellied flycatchers, wood thrush, northern cardinals, bobolinks, whip-poor-wills, kingfishers, great horned owls, and yellow-billed cuckoos may all be observed here.

South of this wilderness is a flat and barren region surrounding Lakehurst, which was one of the world's major arrival and departure bases for the huge, lighter-than-air flying vessels known as zeppelins, airships, or dirigibles. On May 6, 1937, at the conclusion of its third voyage, the *Hindenburg*—considered the safest of all "ships" at the time—burst into hydrogen-fed flames in mid-air just yards above its landing pad at Lakehurst. One of the most noted on-the-spot radio broadcasts of all time occurred when reporter Herbert Morrison found himself broadcasting the biggest story of his career. Listeners glued to their Zenith or Stromberg-Carlson consoles were dumbstruck with horror to hear Morrison's moment-to-moment account which included, "This is one of the worst catastrophes in the world. . . . Oh, the humanity!"

Beyond Lakehurst, State Highway Route 70 merges with County Route 530 and enters the heart of cranberry and blueberry country. Whitesbog Village was founded by Joseph J. White, who concentrated on making the cultivation of cranberries profitable. His daughter, Elizabeth White, planted blueberries on the land between the bogs. The resourceful woman crossed hybrid cuttings from the best wild blueberries provided by locals and developed blueberry bushes that yielded the plumpest, sweetest of berries to be found anywhere in the world. Historic Whitesbog Village is a largely intact example of a cranberry company town; it remains open while undergoing restoration.

Down the road is the entrance to Brendan T. Byrne State Forest, formerly known as Lebanon State Forest. A prime example of Atlantic white cedar swamp can be found in the 735-acre Cedar Swamp Natural Area. The swamp is fringed with pitch-pine forest, and the park has proved ideal for endangered species. The flora

includes rare orchids like the swamp pink, and a timber rattlesnake population is said to center around Mount Misery.

In his 1968 book, *The Pine Barrens*, author John McPhee called Chatsworth "the capital of the Pine Barrens." It is a small commercial center for Woodland Township, where large freshwater lakes feed the cranberry bogs. Surrounded by forest on all sides, development of much of the area is limited by Pine Barrens protection guidelines. There is a general store, built in 1865 and formerly owned by Willis Jefferson Buzby, who was called "King of the Pineys," but the culture McPhee documented has largely changed, and the store is now a giftshop. The book, however, helped preserve the Pine Barrens.

Speedwell today is a cluster of homes by the main road surrounded by a huge modern cranberry plantation. But the side road will take you back in time to Friendship. In the 1860s, industrious farmers began to move wild cranberries from the river's edge to excavated bogs where ore raisers had removed the bog iron. Two Quaker brothers-in-law built one of the largest operations of the time here. Surrounded by picturesque meadows, the remnants of the packing house foundation are not hard to find.

Also off the main road, you will pass extensive cranberry operations again on the way to Oswego Lake in undeveloped Penn State Forest. At this lake in the woods is a small, quiet picnic area, and bald eagles have been spotted in winter. For the adventurous hiker, the trail to Bear Swamp Hill is beyond the lake and offers partial views of the West Pine Plains Natural Area, also known locally as the Pygmy Forest. This stunted woods is a globally rare forest community where the five-foot-tall pines will make you feel like a *giant*. But a warning to the casual automobile explorer, beware the sudden and notoriously soft, white sugar sand—it's easy to get stuck!

THE CARRANZA MEMORIAL

Emilio Carranza, the great-nephew of the beloved assassinated Mexican president Venustiano Carranza, became a hero of aviation in Mexico. After Charles Lindbergh's solo flight to Mexico City in December 1937, Carranza was selected by the Mexican government to follow after Lindbergh with a nonstop solo to New York and then back to Mexico City as part of an official goodwill venture. Carranza took to the air on June 11, 1928, landing in New York after an unscheduled stop in North Carolina due to fog. Determined to make his return flight nonstop Carranza took off in his Ryan monoplane—the same model flown by "Lucky Lindy"—from Roosevelt Field on a rainy July 13, almost immediately encountering fierce thunderstorms over the New Jersey Pine Barrens. Struck by lightning, his plane crashed down not far from the headwaters of the Tulpehocken Creek, a remote section of the Pine Barrens wilderness. A monument to Carranza—a cement pylon twelve feet high, topped by a descending eagle—was erected at the site of the crash and reads "Captain Aviador Emilio Carranza, Muerto Tragicamente el 13 de Julio 1928." To reach the monument, go over the bridge at Friendship and head north on Carranza Road. It will be on the left.

RIGHT: *Over centuries, tannins from plant decay tone and acidify the pure, abundant water, which dissolves out the iron in underlying sands to create the famous "tea colored" rivers of the Pine Barrens.*

BELOW: *At the crossroads of Friendship, the tumbling foundation of a packing house and nearby overgrown impoundments whisper of one of the largest cranberry operations of a time since passed.*

UPPER LEFT: *Sticky globules capture insects on the stems of the rare thread-leaved sundew in an adaptation to nutrient-poor soils.*

UPPER RIGHT: *The nearest relative of the golden crest is found halfway around the world in Australia.*

LEFT: *Spring catkins dangle from a blackjack oak. Well adapted to fire, this oak predominates, along with pitch pine, in the Pine Barrens. Today, prescribed burns are employed by the Forest Fire Service.*

THE LONG AND HAPPY ROAD TO CAMDEN
WHARTON STATE FOREST AND
THE HOME OF WALT WHITMAN

ROUTE 26

Enter Wharton State Forest at Batsto on County Route 542, where the forest office has maps. (Some roads are not suitable for all vehicles. An alternate route is County Routes 542 and 693 west to U.S. Highway 206, north to Atsion.) Batsto-Washington Road will take you to the five corners at Washington. Turn around, and at the fifth corner (south of the crossroads) take the right fork onto Quaker Bridge Road through to Atsion Village. Cross U.S. 206 and continue on Atsion Road to the Dellette crossroads in Indian Mills. Turn left on County Route 534 and continue west through Berlin to Clementon. Take the right fork onto Chews Landing Road (County Route 683) and drive west to Chews. Turn right (northwest) onto the Black Horse Pike (State Highway Route 168), and then right on Kings Highway (County Route 551 Spur) to Haddonfield. Continue north on Kings Highway, turn left (west) on Park Boulevard, left on Kaighns Avenue, and right on Haddon Avenue to arrive in Camden.

This route begins at a crossroads deep in the woods of Wharton State Forest, in a place that feels empty now but was once a major intersection for Pine Barrens traffic. The hamlet of Washington, or Five Corners as it was known, was the site of Sooy's Tavern, an important coach stop on the Camden-Tuckerton stage road. Sooy is a German name, perhaps supporting the popular notion that Hessian deserters from the Revolutionary War battles at Trenton and Princeton helped to populate the "get away" wilds of the Jersey Pines. Elections, suppers, weddings, and regular drills of the militia were held here, but all you'll find of that time is the few tumbling stone ruins of a stable around the corner.

Take the Quaker Bridge Road west, and avoid the side roads. Hunters, woodcutters, colliers, moss gatherers, and ore raisers have all left the mark of their most direct route to the iron furnace, glassworks, or landing. And outlaws, the notorious Joe Mulliner was known to waylay stagecoaches along this road. Thompson's Tavern once stood at Quaker Bridge on the Batsto River. The first bridge was built in 1772 in memory of Quakers who died fording the river on the way to an annual meeting in Tuckerton. In 1805, or 1808, botanists staying at the inn discovered the curly grass fern upstream, and Quaker Bridge gained international renown for a while. Only a bridge and the ferns remain.

The old ironmaster's mansion at Atsion, where Ephriam Clines' Hotel once stood, warns of a highway to cross before continuing by Atsion Lake. The old Atsion Road continues through the outskirts of Indian Mills; the name indicates that this was once the Brotherton Reservation, America's first until 1802, when the last of the Lenapi were removed to upstate New York. At a crossroad in open fields called Dellette, two stone markers indicate the locations of a tavern and a later hotel.

Berlin was another stagecoach stop on the upper branch of Egg Harbor River. The Lenape called it *Lonacoming*, or "many paths or waters meet," but for a while travelers waiting for the stage called it "long-a-coming." A short jaunt west of Berlin is Clementon. The spectacular Clementon Amusement Park and Splash World is on a forty-acre site with a fifteen-acre lake. Entering the great park, visitors will find a giant Ferris wheel, a Thunderbolt, an Inverter, and other fun rides and amusements, as well as six water attractions. The park opened in 1907 and is one of the very few authentic ones left from those golden days.

Alongside the Kings Highway in Haddonfield is New Jersey's first state historic site, the Indian King Tavern, built in 1750. The gabled and pent roofs of this venerable tavern and inn provided shelter for travelers on the old road from Burlington to Salem. Here, in 1777, the New Jersey

General Assembly declared New Jersey a state, not a colony. Later, the General Assembly adopted the Great Seal while at Indian King Tavern. Today, the museum offers an authentic restoration, including the second floor Assembly Room and first floor public rooms of a typical eighteenth-century roadside attraction.

The town of Haddonfield was founded by Elizabeth Haddon in 1698. With no male heirs, her father sent her out to the colonies from England to manage his four hundred acres. The hardy pioneer woman had a house erected and built a still to make medicinal whiskey to help cure members of the Unalachtigo tribe of the Lenni Lenape. It is legend that she also set about making John Estaugh—a Quaker missionary—her husband, astonishing him by proposing marriage in a direct rather than a discreet, coy, or coquettish manner. Her remarkable story is told in "The Theologian's Tale" from *Tales of a Wayside Inn* by Henry Wadsworth Longfellow.

You will enter Camdentown, as it was called in colonial days, along the Cooper River Lake. In 1681, William Cooper built a home on land just below the Cooper River and named it Pyne Point. It was later called Camden by his descendant, Jacob Cooper, after the Earl of Camden, who was sympathetic to the colonies. In 1773 Jacob laid out forty acres and started a real-estate boom. There are still four houses built by the Cooper family in Camden. Pomona Hall, as it was called in 1788, was built in the style of a Georgian plantation house, and the historic brick mansion exists today as a walk-in museum where the parlor and other rooms are furnished in the style of the eighteenth century.

The poet Walt Whitman lived in Camden and said, "Camden was originally an accident, but I shall never be sorry I was left over in Camden. It has brought me blessed returns." Whitman's personal memorabilia, manuscripts, and photographs can be seen in his house at 328 Mickle Boulevard, which is maintained as a small museum. Also visit Johnson Park in the shadow of the former RCA Victor headquarters (at 201 Front Street), once the world's largest producer of phonograph records, radios, and television sets; and Pyne Point Park on the Delaware River, adjacent to Cooper Point, where a stage coach rider would have taken the ferry to Philadelphia.

THE WATERS OF THE PINE BARRENS
HAMMONTON TO BASS RIVER STATE FOREST

Called the "Blueberry Capital of the World," the town of Hammonton is the center of the blueberry industry and also home to the state's largest blueberry plantation, which encompasses two thousand acres. Settled by William Coffin in 1812, Hammonton was originally a peach-growing area and a sawmilling, glassmaking, and farm center.

In 1645, Eric Mullica, a Swede, sailed up the river that now carries his name. Not far from his settlement—which also carries his namesake—just

The poet Walt Whitman, whose most famous work was the collection Leaves of Grass, *spent his final years in Camden. He was buried in Camden's Harleigh Cemetery in 1892.* Photo courtesy of the Library of Congress, LC-DIG-ppmsca-07546

ROUTE 27

From Hammonton, follow Central Avenue and Pleasant Mills Road (County Route 542) east to Wharton State Forest. Continue past Pleasant Mills and Batsto on County Route 542, then detour south on County Route 563 to the village of Green Bank on the Mullica River. Return to County Route 542, continue east, cross the Wading River, and turn left on Leektown Road (County Route 653). Join County Route 654, but continue straight on Stage Road to Bass River State Forest.

ABOVE: *The Pinelands National Reserve was designated a United Nations Biosphere Reserve in 1983. Fifty-four threatened or endangered plant species are afforded special protection here.*

RIGHT: *Broom crowberry occurs in only a few, widely separated populations on the East Coast.*

A diversity of twenty-three northern and southern species of orchids—including the grass pink orchid—thrives in a variety of wetland habitats.

With a vast aquifer close to the surface, the damming and diking throughout the Pines over the years has enhanced the abundance of sphagnum bogs. Botanically productive, these bogs have been a great attraction for naturalists since the early 1800s.

A red-and-white can of Campbell's condensed tomato soup had been a staple of American pantries long before Andy Warhol turned it into a Pop Art icon in the 1960s. Warhol liked to remember his mother preparing Campbell's soup for him as a boy, which she served hot for lunch along with a tuna fish, bologna, or egg salad sandwich, always on Sunbeam "enriched" plain white bread. Warhol's penchant and preference for tomato soup led him to first use the can in his huge, silk-screened artworks. Many times, as a publicity stunt, the bewigged, white-haired Warhol would lead an entourage of his Silver Factory superstars to food chain establishments, like the White Castle in Camden, to autograph cans of Campbell's soup.

The Campbell Soup Company was founded in Camden in 1869 by Joseph Campbell, a fruit merchant, and Abraham Anderson, an ice-box manufacturer, to produce and can Jersey tomatoes and vegetables, as well as fruit jellies. In 1897 condensed soup in a tin was first produced; and in 1898 the first litho-on-paper red-and-white label—inspired by the Cornell University football colors—was introduced into the marketplace.

In 1904, Grace Wiederseim created the "Campbell's Kids," which became the company's advertising trademark and happy mascots used in magazine and newspaper ad campaigns. The sales slogan, "M'm! M'm! Good!" often accompanied the illustration of the cherubic, rosy-cheeked boy and girl as they went about their seasonal playtime adventures. These two kids were said to have been inspired by the popular kewpies of Rose O'Neil. Official Campbell's Kids send-a-ways and giveaways included salt and pepper shaker sets, mugs and cereal dishes, spoons, dolls, cookie jars, recipe booklets, and more.

Throughout the Great Depression, Campbell's soups, canned beans, and franks were used to provide the basis for a cheap meal in hard times. As the economy recovered and the years passed, the first Campbell's soup plant in Camden came to be regarded as a relic of an earlier industrial age, and the company demolished it in 1991. Today, Campbell's World Headquarters (and the Campbell's Museum) are located in a quadrangle called Campbell Place in Camden, and continues on as it has since 1876. Joseph Campbell once said that, for him, it all started with a red-ripe Jersey tomato.

Who hasn't enjoyed a warm bowl of Campbell's soup at the first sign of the sniffles? This vintage advertising promises, "Eat Soup and Keep Well."

beyond the river's forks, the Lenni Lenape had a summer village, where early missionaries visited. Stop by the small church on the side of the road at Pleasant Mills on the Mullica. When a log meeting house occupied this site, an early deed shows an "Indian *Batstu*" located on the other fork nearby. With its origins from the Swedish word for "steam bath" or "bathing place," the name evokes the appeal of the purity of these waters. The forks came to be a principal landing for privateers in the American Revolution, and Batsto provided the cannon.

The Pines' acidic waters leach iron from the sands, which is deposited on the rivers' bank. This bog iron prompted early industrialization, and an iron furnace was in operation at Batsto in the 1760s. A furnace consumed a thousand acres of pine for fuel each year, however, and the Batsto Furnace blew out for the last time in 1848. In 1876 Philadelphia industrialist Joseph Wharton purchased the old workers' village for his estate. He remodeled the iron-master's mansion with an eighty-foot tower, grand porches, and a Victorian façade. Wharton's dream to provide water to Philadelphia never materialized, however, and the 96,000 acres he amassed were sold to the state of New Jersey in the 1950s. Batsto Village and its mansion are available to tour, as are the woodland tracts from the core of Wharton State Forest.

The Batsto Natural Area encompasses the cedar swamps, quaking sphagnum bogs, cripples, savannas, and spongs of the floodplains of the Batsto and Mullica Rivers above the original *Batstu*. It may be best explored by canoe. Look for the golden sheen of rare bog asphodel over the water from the distance. Listen for the "quonk quonk" of the rarer Pine Barrens tree frog on a quiet spring evening. Primitive campsites may be reserved.

The Batsto, Wading, and Bass Rivers all join the Mullica River and add their fresh waters to the brackish Great Bay in the marshes of Edwin B. Forsythe National Wildlife Refuge. East of Batsto, a park sign marks Crowley's Landing for extensive views of the Mullica River. A scenic river crossing is located at the historic landing near the village of Green Bank. Especially in the winter, eagle sightings are not unusual in the vicinity of the Wading River bridge. Portions of the floodplain of the East Branch of Bass River are protected in the 128-acre Absegami Natural Area of Bass River State Forest. The exotic flora here is somewhat similar to that of the southern state of North Carolina. With an abundance of wildlife, the half-mile nature trail that begins at Lake Absegami is a pleasant detour for birdwatchers. It is easy to get to civilization from here—continue east on Stage Road, and you will soon find yourself in Tuckerton, situated on the Little Egg Harbor.

A DELSEA DRIVE
EXPLORING THE DELAWARE BAYSIDE

Rio Grande is a little Wild West town just inland from the Wildwood Atlantic Ocean beaches on the east side of the Cape May Peninsula. It is at the junction of U.S. Highway 9 and Delsea Drive (State Highway Route

ROUTE 28

From Rio Grande, take State Highway Route 47 (Delsea Drive) north to Goshen. Turn right onto Goshen-Swainton Road (County Route 646) to U.S. Highway 9, and go north to Clermont. Turn left onto State Highway Route 83 and then right onto Highway 47 to North Dennis. Go right on Washington Avenue (County Route 557) and left on County Route 550 to the entrance of Belleplain State Forest. Take the first right, onto Henkinsifkin Road, to Lake Nummy. Henkinsifkin turns into Franks Road, and take that to a right on Sunset Road. Follow Sunset Road to a left on Hands Mill Road (County Route 550 Spur). Continue straight on County Route 651 to Highway 47 west, turn left on Glade Road (County Route 616), and go straight on East Point Road to the lighthouse. Return to Highway 47 north, turn left on County Route 670, cross the Maurice River, and follow County Route 649 to Port Norris. Go right on Main Street (County Route 553) and take a left on County Route 631 to Bivalve.

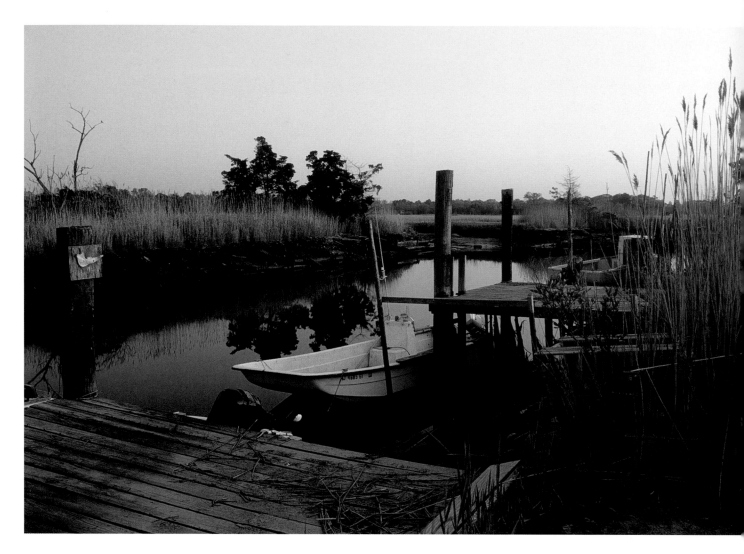

ABOVE: *Ships weighing a thousand tons were once built on Dennis Creek in the Delsea Region. Traces of an old log corduroy road can be seen on the far bank.*

RIGHT: *Shellpiles in Shellpile. At its peak, ninety railroad cars full of oysters left this area for Baltimore every week.*

ABOVE: *Sanderlings, red knots, and ruddy turnstones time their long-distance migration to gorge themselves on tons of tiny horseshoe-crab eggs each spring.*

LEFT: *The A. J. Meerwald,* New Jersey's *official tall-ship, is a bald-headed, gaf-rigged schooner. She was one of hundreds of oyster dredges that once plied the waters of the Delsea.*

The Lenape natives would burn woods to open the light for their crops and increase forage for their prey. After seven years they moved on to a new location and let the land restore itself.

ABOVE: *A cornucopia of fruits and vegetables, fresh from the Garden State.*

LEFT: *As city commuters build more homes in rural areas, the peach industry is moving south from Gloucester County to Salem and Cumberland Counties.*

ROUTE 29

From Vineland, take State Highway Route 47 south to Millville. Follow the signs to WheatonArts at 1501 Glasstown Road. Take State Highway Route 55 north to Exit 32, go west on State Highway Route 56, and take an immediate right on Maurice River Parkway, then left (west) on Almond Road (County Route 540). Follow County Route 540 through Centerton to Husted, then turn left on Northville Road (County Route 711) to State Highway Route 77 south. In Bridgeton, drive west on State Highway Route 49. At Pecks Corner, turn left onto Pecks Corner–Harmersville Road (County Route 667). Cross Main Street in Harmersville and follow County Route 658 to Salem–Hancocks Bridge Road, which becomes Yorke Street, into Salem. Take Highway 49 north to Harrisonville. Turn left on Lighthouse Road (County Route 632) and left on Fort Mott Road (County Route 630) to Fort Mott State Park and Finns Point.

Consumers in New York City, Philadelphia, and the rest of the country are supplied with fruit and vegetables by the "garden spot" of the Garden State: the counties of Burlington, Gloucester, Salem, and Cumberland. People flock to roadside stands in these counties during the growing season for their share in Jersey's cornucopia. Vineland and Camden are farm-industry centers, and the farm bounty destined for their canning houses or fresh produce markets includes the ubiquitous Jersey tomato, endive, "sweet Jersey corn," string beans, beets, cabbage, carrots, cantaloupes, peppers, onions, cucumbers, squash, pumpkins, peaches, and more. From as early as April—for asparagus—to as late as December—for cauliflower—U-pick-it farms allow visitors and residents to enjoy harvesting their own produce.

At sixty-eight square miles, Vineland registers as the largest city in New Jersey, but it is actually a town in the center of a large agricultural tract. In the mid 1800s, Charles K. Landis, a Philadelphia lawyer and banker, bought 32,000 sandy acres of pine and scrub oak here and sold five- and ten-acre plots to large numbers of Jewish and Italian immigrants eager for a chance at the American dream. Vineland was a "dry" town, and Dr. T. B. Welch, a local dentist, came up with the idea of preserving grape juice, without fermenting it, for Communion at the local churches—and so began the gigantic Welch's Grape Juice empire. The Vineland Cooperative Egg Auction began in 1931, and the town became known as the "egg basket of the nation." New technology lowered prices and brought a decline; the auction closed in 1973. Today Vineland is home to the largest farm co-op east of the Mississippi. The Vineland Cooperative Produce Auction can cool two-hundred-thousand packages in a twenty-four-hour period.

At the head of the tidewater of the Maurice River, Millville was established in 1790 as a glassworks by Quakers, who successfully utilized the abundant water and sand of the river. Carl Sandburg wrote in his book of poetry, *In Reckless Ecstasy*, "Down in Southern New Jersey they make glass. By day and by night, the fires burn on in Millville and bid the sand let in the light." The first glass factory was established here in 1806 by T. C. Wheaton. Today you can tour the WheatonArts and Cultural Center and see the glass craftsmen demonstrating centuries-old glassmaking techniques at the factory—shaping, blowing, and molding. Formerly called Wheaton Village, it is also the home of the Museum of American Glass, which has the largest collection of American glass in the country.

Continuing north and west, you will reach 1,137-acre Parvin State Park and its Parvin Natural Area, a diverse habitat at the ecological transition from the outer to the inner coastal plain. Take the Forest Road Loop amongst the black oak and pine. Clearly marked hiking and riding trails circle Parvin Lake, and a shady picnic grove, canoe rental, boat launch, and sandy beach are a big draw in the summer. Cabins are available to rent at Thundergust Lake, which is a renowned fishing spot, as are Parvin Lake and Muddy Run. The remains

of five ancient Native American encampments have been found by archaeologists in the forests of this hidden gem of the state park system.

As you pass through Seabrook Farms, note the Garden State history surrounding you. Charles F. Seabrook began his agricultural empire here in 1900 with a fifty-seven-acre farm. By 1912 the farm had been built up to three thousand acres, and before it was sold in the 1960s it had become the largest agricultural enterprise in the state and one of the largest in the world, owning nineteen thousand acres and leasing forty thousand acres from other farmers. Quick freezing, developed in the 1930s by a Seabrook employee named Clarence Birdseye, stimulated a big jump in the production of vegetables and other produce, particularly fruits and berries.

Bridgeton, established by the Quakers in 1686, is a small city of canneries, glass factories, and the state's largest historic district, comprising over two thousand Colonial, Federal, and Victorian houses. Located in the center of Bridgeton's 1,110-acre Tumbling Dam Park is Sunset Lake, which was formed by a dam in 1814. This is the place for bathing and fishing, with catches including largemouth bass, pickerel, bluegill, and yellow bullhead perch. Also located within Bridgeton borders is the Cohanzick Zoo—the first zoo in the state—known for its rare white tigers as well as two hundred other animals. For more entertainment, head to the Cohansey riverfront. Events take place all year long in this little city that has kept its heritage intact for over two hundred years.

Quaker John Fenwick brought his family to settle in West Jersey in 1675 and named the first permanent community in the region New Salem, after the ancient Hebrew word for peace, *shalom*. The famed Salem Oak, an iconic tree which you can still see today, was two hundred years old when Fenwick made a treaty under its spreading boughs with the Lenni Lenape.

This area was not always a peaceful place, however. "Go—spare no one— put all to death give no quarters." These were the words given to British troops on March 20, 1778, by General Charles Mawhood, who was in command of 1,500 men foraging the region for desperately needed supplies. The general was chagrined over his defeat at Quinton's Bridge and was intent on punishing the local farmers, who, in sympathy with the colonial militia, had already given George Washington's army enough supplies to last until spring. At 5 a.m. on March 21, three hundred men under British Major John Graves Simcoe descended on Salem, attacking the house of His Imperial Majesty's Royal Advocate for Salem County, Judge William Hancock, where they mistakenly thought a large force of revolutionaries were hiding. In the following massacre, over a dozen innocent people—mostly civilians—were bayoneted and killed, including the judge who was actually an official in the British Colonial government (though sympathetic to the American cause).

Hancock's ancestor, an English shoemaker, had bought approximately five hundred acres in Salem in 1675, and the prominent Hancock family went on to improve the area, building a bridge over Alloways Creek in 1708 and the impressive Hancock House in 1734. Located at 3 Front Street in Hancocks Bridge, this extraordinary home features extensive, patterned

On the fringes of the Pine Barrens, the diversity of the upland forest surrounding Parvin Lake provides some of the best bird-watching in the state.

This 1734 Quaker patterned-brick house was built on Alloways Creek with Flemish-bond coursing on the front and back, while the end walls feature a "diaper" design and the date and the initials of owners William and Sarah Hancock.

brickwork. From 1761 to 1870 a section of the house was used as a tavern. The historic home stayed in the family until 1911, and in 1931 New Jersey acquired it for a mere $4,000. After a period of neglect and following a comprehensive restoration, Hancock House was re-opened to the public on March 21, 1998, on the 220th anniversary of the Salem County slaughter. The house is listed in State and National Historic Registers.

In colonial times, great quantities of rice were grown in the Supawna Meadows, where today shorebirds appreciate the bounty of this National Wildlife Refuge. The 2,880 acres of mostly brackish tidal marshes are located in an unspoiled, isolated region with great scenic beauty. The Finns Point Rear Range Light was built here in 1877, restored in 1983, and is now on the National Register of Historic Places. It is a black tower 115 feet high and was used as a navigational focus for mariners on the Delaware Bay until it was decommissioned in the 1950s, when it had become obsolete. The cast-iron staircase in this historic lighthouse is the pièce de résistance.

Fort Mott State Park, situated on 104 acres on Finns Point, was America's earliest defense of its first ports. It was acquired in 1838 by the federal government to fortify the mouth of the Delaware River and was outfitted with twelve-inch coastal defense guns for armament, but this fort "never fired a shot in anger" during the Civil War. Today, there are playgrounds, picnic areas, and excellent fishing and crabbing spots here. In Finns Point National Cemetery lie the graves of 2,436 Confederate Civil War prisoners—who died at Fort Delaware, an Elba-like prison on nearby Pea Patch Island—as well as several hundred Union soldiers. A beacon of the history that is to be found in New Jersey, this site was designated a national cemetery over a century ago, in 1875.

THE STORY OF THE JERSEY TOMATO

The tomato was discovered in South America by Spanish conquistadors, who then introduced it to Europe in the sixteenth century. The French used the small, red fruit as a token of love, and Italians discovered its value in making sauce. Ephraim Buck of Cumberland County, New Jersey, began experimenting with tomato seeds brought from Florida in 1812. Since the turn of the twentieth century, Jersey canning companies like the Campbell's Soup Company, H. J. Heinz, Seabrook Farms, and others have worked to develop the large, luscious, and highly nutritious Jersey tomatoes of today, introducing tomato juice made from their breeds in 1931. Other delicious tomatoes grown in the Garden State include big, pink beefsteaks; acid-free golden yellows; tasty green or deep-red "Heirlooms"; and the rare, fruity whites.

In 1934 the New Jersey State Agricultural Experiment Station in New Brunswick developed one of the state's most celebrated tomato varieties. It was a vigorous, disease-resistant, early-bearing, free-setting, heavy-fruiting strain of tomato with excellent color, size, and acid and sugar content. Named the "Rutgers" in honor of its affiliate, Rutgers University's Cook College—the first agricultural school in the country—it ripens from the center out, contains few seeds, has a hearty, sweet flavor, and grows with an abundance of foliage that protects it from sunscald.

Since 1925 truck farms in the state have declined from thirty thousand to only a few hundred, but tomato wholesalers like Apache Brand and resilient, individual farmers continue to sell tons of fresh Jersey tomatoes every year.

SUGGESTED READING

Brown, Michael P. *New Jersey Parks, Forests, and Natural Areas.* New Brunswick, NJ: Rutgers University Press, 1991.

Cunningham, John T. *New Jersey: America's Main Road.* Garden City, NY: Doubleday & Co., 1966.

Cunningham, John T. *This Is New Jersey.* New Brunswick, NJ: Rutgers University Press, 1953.

DeWire, Elinor, and Paul Eric Johnson. *Lighthouses of the Mid-Atlantic Coast.* Stillwater, Minn.: Voyageur Press, 2002.

Genovese, Peter. *New Jersey Curiosities.* Guilford, Conn.: The Globe Pequot Press, 2003.

Gold-Levi, Vicki, and Lee Eisenberg. *Atlantic City: 125 Years of Ocean Madness.* New York: Clarkson N. Potter, 1979.

Heide, Robert, and John Gilman. *New Jersey: Art of the State.* New York: Harry N. Abrams, 1999.

Heide, Robert, and John Gilman. *O' New Jersey.* 3rd ed. New York: St. Martin's Press, 2006.

Hine, C. G. *The Old Mine Road.* Reprint ed. New Brunswick, NJ: Rutgers University Press, 1985.

Martinelli, Patricia A., and Charles A. Stansfield Jr. *Haunted New Jersey.* Mechanicsburg, Penn.: Stackpole Books, 2004.

McCloy, James F., and Ray Miller Jr. *The Jersey Devil.* Wallingford, Penn.: The Middle Atlantic Press, 1976.

McPhee, John. *The Pine Barrens.* New York: Farrar, Straus & Giroux, 1968.

Moran, Mark, and Mark Sceurman. *Weird N.J.* Vol. 1. New York: Sterling Publishing, 2004.

Moran, Mark, and Mark Sceurman. *Weird N.J.* Vol. 2. New York: Sterling Publishing, 2006.

Pike, Helen-Chantal. *Asbury Park's Glory Days.* New Brunswick, NJ: Rutgers University Press, 2005.

Scofield, Bruce, et al. *Fifty Hikes in New Jersey.* Woodstock, Vt.: Backcountry Publications, 1988.

Williams, Bob, and Craig Maier. *A Place Called Walpack.* Hibernia, NJ: DVD Documentary, Diamond Cut Productions, 1987

ACKNOWLEDGMENTS

We would like to thank the following individuals and organizations for their assistance in the creation of this book: George Bonanno, Jerry Fabris at Edison National Historic Site, Robert Dahdah, Peter Gilman, Alyn and Sally Heim of the House by the Sea in Ocean Grove, Madeline Hoffer, Stephen Hooper, Linda Jonasch, Brian Lehrer, Peter Leiss, Craig Maier, Carol Overby, Rochelle Owens, Jerry Pagano, Jeff Painter, Robert Patrick, Scott Rodas at the Toms River Library, Joyce and Gordon Tretick, Jeff Weiss, Diamond Cut Productions, the New Jersey Federation of Women's Clubs, the New Jersey Historical Society in Newark, and Margret Aldrich and Josh Leventhal of Voyageur Press. — RH and JG

Unless otherwise noted, all vintage postcards, booklets, brochures, and other ephemera are from the Robert Heide and John Gilman Jerseyana Collection.

INDEX

ABOUT THE AUTHORS AND PHOTOGRAPHER

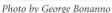

Photo by George Bonanno

ROBERT HEIDE AND JOHN GILMAN

PAUL ERIC JOHNSON

Robert Heide (left) and John Gilman (right) have co-authored more than a dozen books on travel and American popular culture, including *New Jersey: Art of the State, O' New Jersey, Dime-Store Dream Parade, Popular Art Deco*, and more. Gilman and Heide are both based in New York City and make frequent trips to the Garden State. They are the subjects of a Jersey roadtrip documentary by Peter Leiss, called "Cake Walking Babies from Home."

Paul Eric Johnson is an environmentalist and photographer whose images have appeared in books, magazines, and calendars throughout the world. Johnson's most recent book, *Lighthouses of the Mid-Atlantic Coast*, was published by Voyageur Press. He is the Director of Photography for the Wohlfarth Galleries in Provincetown, Massachusetts, and Washington, D.C., and lives in Hopatcong, New Jersey.